IMAGES
*of America*

# HAMPDEN

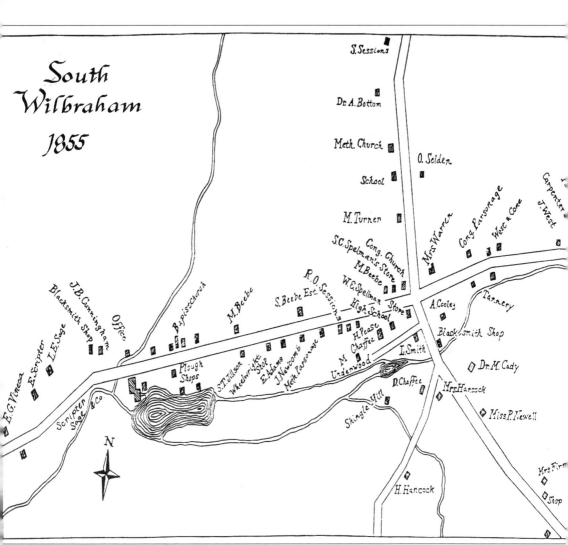

The narrow parallel lines on this 1855 map denote the Scantic River and its tributaries.

IMAGES
*of America*

# HAMPDEN

Evelyn Griggs Schoolcraft

ARCADIA

First printed in 2002.

Published by Arcadia Publishing,
an imprint of Tempus Publishing, Inc.
2A Cumberland Street
Charleston, SC 29401

Printed in Great Britain.

Library of Congress Catalog Card Number: 2002100839

For all general information contact Arcadia Publishing at:
Telephone 843-853-2070
Fax 843-853-0044
E-Mail sales@arcadiapublishing.com

For customer service and orders:
Toll-Free 1-888-313-2665

Visit us on the internet at http://www.arcadiapublishing.com

*Dedicated to the memory of my parents, Waldo and Esther Griggs; to my brother Allen; to the Griggs and Kronvall families; and to my husband, Bob, and our children, Holly, Bob, Laurie, and Allen,and their families, with thanks for all the help they have given to me now and through the years.*

# CONTENTS

# ACKNOWLEDGMENTS

My heartfelt thanks go to the following people for sharing their expertise, knowledge, and pictures so that this book might be completed: Nancy Ayers, Elaine Evans, Molly Hickey, Betsy Johnson, Patricia Smith, Honor Twomey, Dorothy Gulbrandson, Ellen Bump, Chrissy Cesan, David Cesan, Helen Dickinson, Miles Hapgood Jr., Rev. Thomas Howells, Betty Dunlea Connors, Virginia Schneider, Edward Speight, Dale Ruff, Norman B. Pike, M.D., the Hampden Free Public Library, the Ashfield Historical Society, and the Springfield Newspapers. I give special thanks to the Historical Society of the Town of Hampden and especially to its president, Linda Krawiec, who has given me so much of her time and experience.

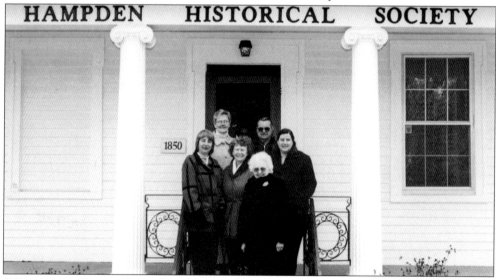

Officers and a few members of the Historical Society of the Town of Hampden stand on the front steps of Academy Hall, which was built in 1850 as South Wilbraham Academy. From left to right are the following: (front row) Dorothy Hill; (second row) Linda Krawiec (president), Evelyn Griggs Schoolcraft, and Nancy Ayers (secretary); (back row) Rita Vail (treasurer) and Robert Schoolcraft. (Photograph by Tracy L. Bliss.)

# INTRODUCTION

In 1674, Native Americans sold Springfield leaders the Outward Commons, part of which later became Wilbraham. Stephen Stebbins, credited as the first settler in the southern parish (called South Wilbraham, but not a separate town), built his house in 1741. However, two houses already existed here, perhaps constructed by Edward Pynchon and the Hitchcocks. The year 1750 brought the first sawmill, and in 1763, Wilbraham was incorporated. Robert Sessions of South Wilbraham took part in the Boston Tea Party in 1773. Through 1775, townsmen fought in the Revolutionary War and in every war thereafter. In 1780, Massachusetts freed all slaves. At least three houses in South Wilbraham were stations on the Underground Railroad. The masters of two slaves hidden by Edward Morris in his attic on South Road fought to recapture them, only one slave escaping. In 1781, Capt. Steward Beebe built a large brandy distillery on North Road. A Congregational church was built in 1783, and the first minister, Rev. Moses Warren, arrived in 1789. On North Road, the first schoolhouse was built in 1796. Scantic, Hendrick (or Newall), West Side, Robert Sessions, and Center Schools came later. Rev. Stephen Williams, "Boy Captive of Old Deerfield," owned land in the area. His son John built three houses. The militia trained from 1792 to 1812.

Edwin Chaffee, who discovered how to apply rubber to cloth, was born in 1806. The year 1810 saw the birth of Rev. Rufus P. Stebbins, D.D., great-grandson of Stephen Stebbins and a founder and president of the American Unitarian Society. In 1819, Andrew Jackson Davis, multimillionaire copper king, was born on South Road. Edwin Chaffee patented his process in 1836. His Roxbury Rubber Company eventually became the Goodyear Manufacturing Company. A sawmill and gristmill operated in 1840, and South Wilbraham Academy was built in 1850. The building is now the home of the Historical Society of the Town of Hampden and its museum. The Baptist church was built in 1854. In 1858, the first large mill at the ravine, Scripter Sage & Company, made 1,000 yards of satinet daily. This became the Lacousic Woolen Mill, producing 16,000 yards of fancy cassimere (soft woolen cloth) monthly. The Methodist Episcopal church was moved from North Road to Main Street in 1859 and later became the Federated Community Church of Hampden. What is now the front of the church was originally its back.

A shoddy (reclaimed wool) mill began in 1860, and the Scantic Woolen Mill manufactured fancy cassimere in 1865. A Roman Catholic priest from Monson provided Mass in private homes in 1869. Lucetta (Chaffee) Howlett gave land for Prospect Hill Cemetery, with the provision that no one ever be charged for a burial lot. In 1877, the Scantic Woolen Mill was

taken over by the Kenworthy family to make yarn and blankets. On March 28, 1878, the south parish (South Wilbraham) was incorporated and named Hampden. The first Ravine mill burned that year. The year 1879 saw the erection of the Ravine Manufacturing Company, also called Hampden Woolen Mills. It had 200 large windows and employed 75 people. The portion of the cemetery known as St. Mary's was deeded to the Roman Catholic bishop of Springfield, and the St. Mary's church building was completed.

Eight stores may have existed at one time in what is now quiet Hampden. Chairs, coffins, baskets, and other items were made in the area, and apples and huckleberries were canned. There were blacksmith shops, meat markets, manufacturers of soap and wrapping paper, a clover-cleaning mill, a creamery, a bark mill for tanning leather, sawmills, shingle mills, a cider mill, a millinery store, a potash factory, a tin shop, a lumberyard, a wheelwright shop, a confectionery shop, livery stables, the town pound, a tannery, grocery stores, icehouses, a clothier's shop, plow and wheelbarrow shops, a carding-machine shop, a dye shop, and a country store (in the vestry of the Baptist church, which burned in 1932).

Residents had stores in their homes. There were platform scales to weight hay and charcoal. Corwin "Fish" Kibbe brought his wares to neighboring towns as well. A spiritualist camp meeting ground was on Glendale Road. Allen O. Thresher built charcoal kilns on Rock-a-Dundee Road in 1885. Shoemaker Lucien Winslow was Hampden's lamplighter in the 1890s, walking the length of Main Street at dusk and lighting kerosene oil lamps. In 1891, the town's first public library was established in Delia Lee Adams's home. An anticipated railroad—which was to run between Stafford and Springfield, thus enabling Hampden to send its wares across the nation—failed to materialize. The Lacousic Woolen Mill burned in 1891, and the second Ravine mill burned in 1904, never to be rebuilt. The population dwindled to 490.

Rev. Charles B. Bliss and the young people in town built a popular tennis court on Main Street, and eight children from the closed Newell Schoolhouse were transported by horse and wagon to the Center School in the early 1900s. Albert Lee built a high tower on Pine Mountain in 1910, with a dance pavilion nearby, providing amusement until macadam roads made travel elsewhere possible. Charles Henry Burleigh gave Hampden its World War I memorial in 1920, and in 1923, Ben Libby became Hampden's first scoutmaster. In 1925, John Swenson, with the help of volunteers, fashioned the town's first fire engine, with a 100-gallon tank on a 1921 Cadillac chassis. Swenson was the first chief of Hampden's volunteer fire department. Harry Lyons's dance pavilion burned. In 1926, Nettie Gottsche began the first Girl Scout troop.

Elizabeth Sessions gave Hampden a new town house in 1932, and the Hampden Garden Club began in 1935. An ice plant was built in 1937, lasting only 10 years because of electric refrigeration. Other dates follow: Veterans of Foreign Wars, Pat Ledoux Post No. 9397 (1947); Veterans of Foreign Wars Ladies Auxiliary (1947); Hampden Lions Club and Hampden Housing Project (1948); Rev. John W. Shea becoming first resident pastor of St. Mary's (1951); Green Meadows School (1957); Hampden joining with Wilbraham to build Minnechaug Regional High School (1959); Mary Lyon Nursing Home, and Recreation Association of Hampden (1960); Woodland Park Garden and Women's Club and the Historical Society of the Town of Hampden (1965); Thornton Burgess Middle School (1967); the Massachusetts Audubon Society buying the property of Thornton W. Burgess at Laughing Brook (1967); Hampden Country Club (1974); Hampden Lioness Club (1977); Hampden Housing Project completed (1978); and the Hampden centennial celebration (1978).

Lovely Hampden, with its historic homes, is now a residential community, with most inhabitants employed elsewhere.

# One

# ABOUT TOWN

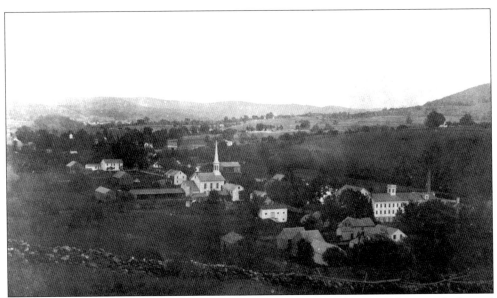

The peaceful village of Hampden nestles below the mountains in this 1885 photograph. Several buildings belonging to the Lacousic Woolen Mill, which provided work for 75 people, are shown at the right. Business was booming. Many workers boarded in town, and several residents kept stores of various types in their homes. At the left is the Baptist church, which once housed Pease's grocery store in its basement.

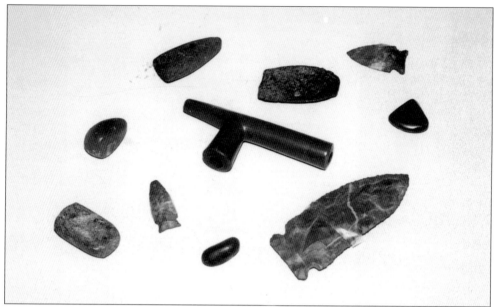

Nipmuck Indians roamed the region's mountains and fished in what was then called the Seantuk River (now the Scantic), which means "whiting fish" or "a branch of a river." Shown is a sampling of Native American artifacts found in Hampden. The pipe appears to be made of stone. The spearhead is broken. Many arrowheads are in the files of the Historical Society of the Town of Hampden. (Photograph by Tracy L. Bliss.)

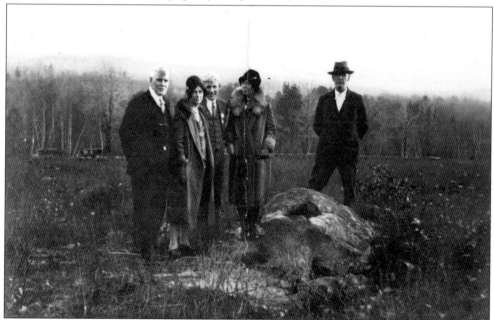

This 1938 photograph shows townspeople gathered around the Native American "roasting" rock, which was later moved to its new vantage point on the lawn in front of the Historical Society of the Town of Hampden. It is believed that Nipmuck Indians built a fire under the ledge at one end of the rock and then placed large chunks of venison in the rock cavity above the fire, roasting their meat.

10

More than 200 years ago, William King's goats scampered over these rocks. One poor animal became entangled and was found dead, thus giving the site its name. In this photograph, Eleanor Burleigh (left), Arline Howlett (center), and an unidentified friend are enjoying a picnic at Goat Rock, with its marvelous view looking toward East Longmeadow and Somers.

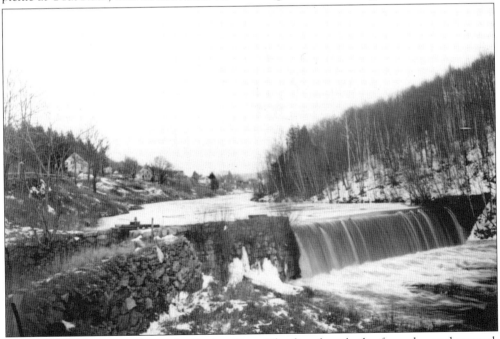

This view, looking east, shows the Ravine Dam. The first dam, built of wood, was destroyed. Davis Pease built the second Ravine Dam in 1867. It consisted of huge stones that were originally dragged by Merritt Pease of Somers and his oxen from the quarry on Chapin Road. The second dam remained for years until it was broken by the deluge after a hurricane.

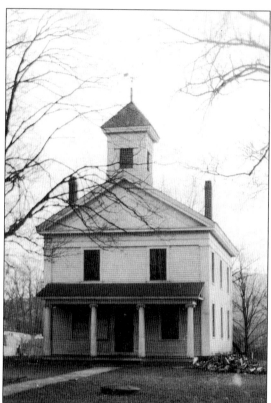

The Ionic pillars of Greek Revival architecture were used when this building was erected as the home of South Wilbraham Academy in 1850. Classes were held here. Eventually, Hampden's town meetings took place in this building, as well as plays and dances, until the new town house was built. Now called Academy Hall, this building is the home of the Historical Society of the Town of Hampden. Its museum occupies the second floor.

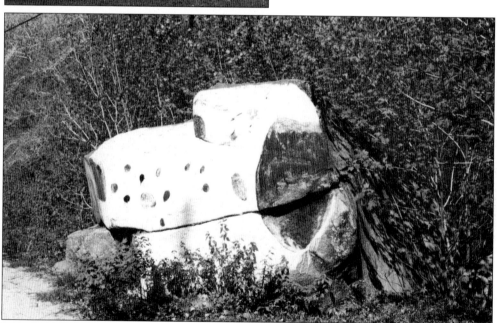

Dog Rock, located on Bennett Road, has been a conversation piece for years, with townspeople trying to determine the names of the creative people responsible for painting the rock, a well-kept secret. Speculation has been widespread, with no one confessing to doing the deed. A recent obituary credited Nola Leone as being one of the painters.

The focal point of this peaceful image is the well-built bridge over Temple Brook, which is a tributary of the Scantic River.

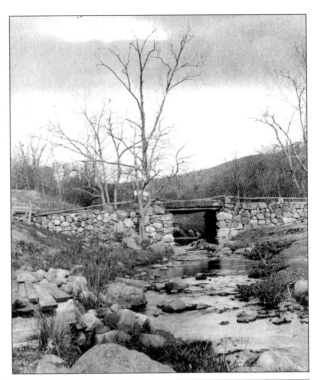

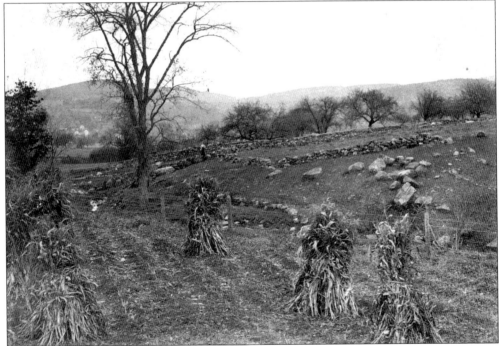

This lovely fall scene shows corn standing in shocks, once a common sight in the area. At the start of the 20th century, the mills that had been destroyed by fire were not rebuilt because the anticipated arrival of the railroad failed to transpire. With no way to transport their products across the country, Hampden people turned back to farming.

Hampden first had a post office in 1826, with appropriately named Dudley Post as the first postmaster. As the town modernized, Hampden's mail was distributed from this facility on Main Street until the new brick post office took its place.

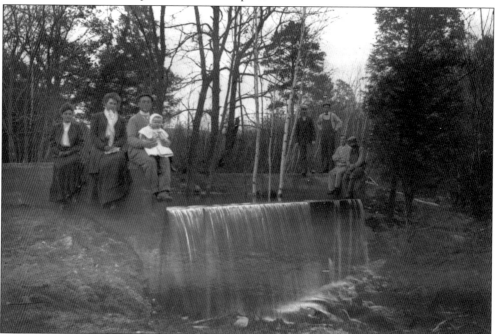

In the early 1900s, a group poses at the Wesson, or Chaffee, Dam on Rock-a-Dundee Road. With few options for amusement and no television in the good old days, families enjoyed walking and viewing nature when they had an idle hour. Note the baby accompanying them on their stroll.

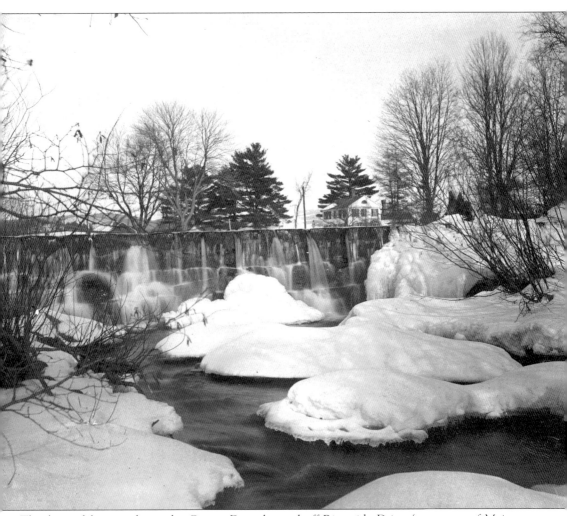

This beautiful scene shows the Center Dam, located off Riverside Drive (once part of Main Street). During a severe winter, the Scantic River sometimes froze into a solid sheet of ice.

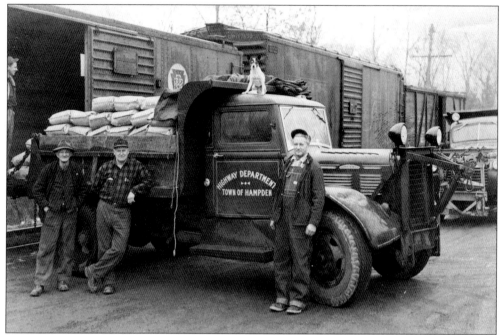

Members of Hampden's active highway department are shown with the town truck, picking up supplies at the railroad. From left to right are Austin K. Harris, Arthur Gerrish, and Bill McCray.

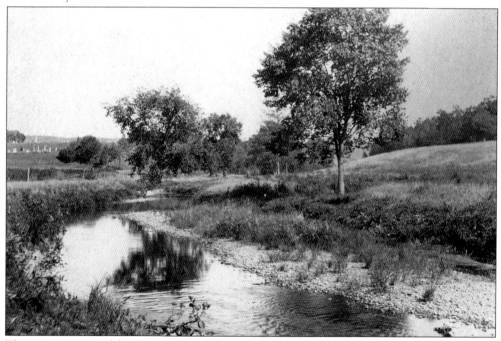

This summer view of the Scantic River was taken looking toward what was then called the new cemetery, the land given to the town by Lucetta (Chaffee) Howlett. The village had more of a rural character in the past. Today's youngsters sometimes tube down the calm section of the river, a great way to cool off on a hot day.

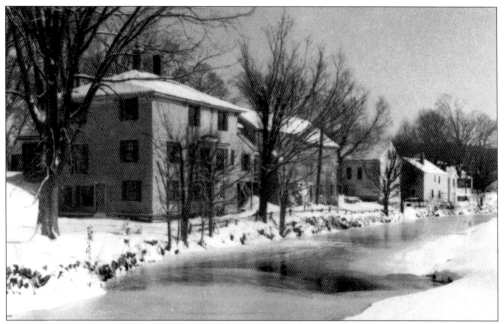

This peaceful winter scene shows the frozen Scantic River and the backs of the houses standing guard over its southern bank.

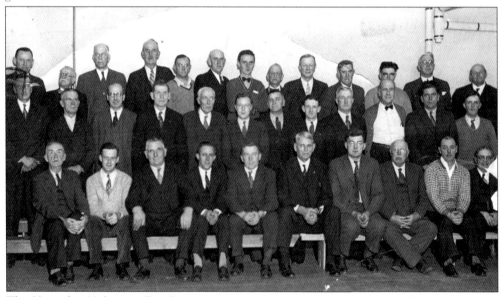

The Hampden Volunteer Fire Department put on an oyster stew supper on January 1, 1936. Pictured, from left to right, are the following: (front row) E.P. Lyons, Carl Officer, L.O. Howlett, George Fisher, Neil Kibbe, Chief Herbert Root of the Springfield Fire Department, Verne Thayer, Nelson Carew, James Lyons, and Charles Medicke; (middle row) H.O. Smith, Homer Hatch, Dwight Moody, Bernard Ackerman, A.H. Newman, Cecil Thomas, Ted Strahan, Earl Simons, W.D. Thomas, Fred Perkins, Emil Scheibler, and Chester Pease; (back row) Herbert Root's unidentified chauffeur, Frank Heath, Charles Ballard, John Flynn, Walter Lyons, Harry Goodwill, William O'Brien, Norman Millard, D.L. McCray, Robert Pease, Harold Corey, Herbert Burnham, and George Chapin.

Charles Ira Burleigh was town treasurer and town clerk of Hampden for a number of years and once owned a store at the corner of Chapin Road and Main Street. He died in 1930.

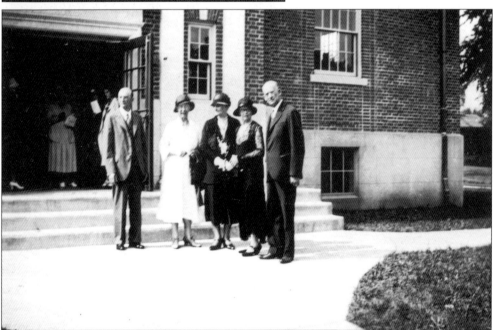

In 1932, Elizabeth Sessions gave Hampden the largest gift it has ever received—a new town house. Standing out front at the dedication are, from left to right, two unidentified people, Jane C. Sessions, Elizabeth Sessions, and William Crighton Sessions.

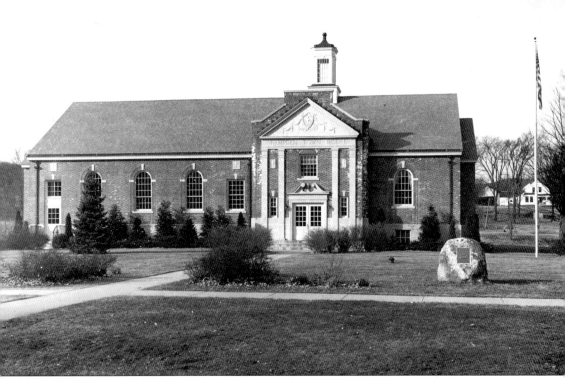

Hampden is proud of the new town house. A door was installed in an existing concrete wall to make an inside entrance to the basement. For years, this town house served as the site of the Hampden Junior High School. At one time, grades one and two were taught in the auditorium. It also provided a meeting place for seniors until the new senior center was built. The town house now holds the library, the police department, and town offices. It is also the site for town meetings, fairs, flower shows, and special town events. During elections, Hampden citizens cast their votes here. Wedding receptions and other festivities have taken place at this site.

Elizabeth Sessions gave Hampden its new town house. An upstairs room at the town house is named after her and displays her picture on the wall.

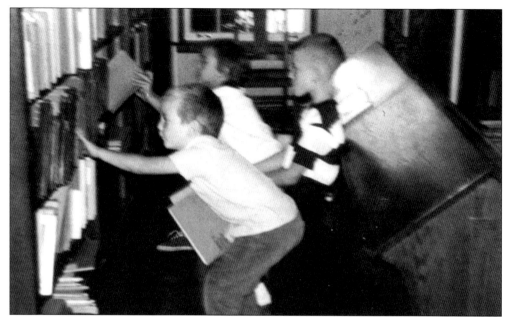

It is evident from this image that youngsters in Hampden enjoy the library and searching the shelves for favorite books. This facility has an active program for Hampden's young people, as well as for adults, and is a popular spot, with a staff always willing to aid the reader.

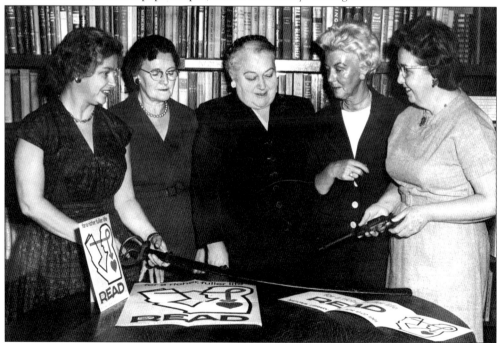

Hampden's first library was established in 1891 in the upper front room of the Main Street home of Delia Lee Adams, who was Hampden's first librarian. Today, Hampden's library occupies a good-sized section of the second floor of the town house. Pictured, from left to right, are Ernestine Johnson, Winifred Buereau, Mildred Attleton, Charlotte Audren, and Edith Maher. (Photo courtesy Springfield Newspapers.)

In 1970, someone found a bomb at the Hampden Dump and excitedly called the police. Shown, from left to right, are two unidentified men from Westover Air Force Base who came to inspect the device, Hampden Patrolman Miles Hapgood Jr., and Patrolman Paul Bouchard. The bomb proved to be a dummy, so Hampden's citizens were not endangered.

## Two

# BUSINESSES

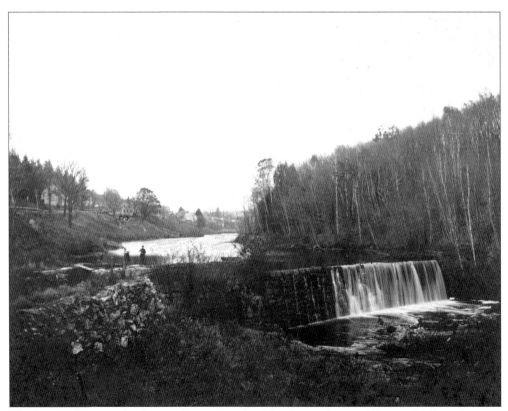

The Ravine Dam on the Scantic River furnished the first and second Ravine Mills with power in the 1800s. The first Ravine Dam was made of wood, parts of which may still exist under the water. The second dam, built by Davis Pease, consisted of large blocks of granite. The two men in the distance may be fishing for trout.

Marcus Beebe, born in 1812, was noted for the fine plows and wheelbarrows he made in his shop. He sent many of the plows to his brother Decius, who owned a store in New Orleans, Louisiana. One variety was especially shaped for use by slaves instead of horses. Imagine a slave on a hot southern day, pulling the plow across a large field, exerting all his energy to make the loam ready for cotton-planting time. Marcus Beebe died in 1891.

.............. **Wheelbarrows.**

.............. **Plows.**

## From MARCUS BEEBE,
### MANUFACTURER OF
# PLOWS, WHEELBARROWS, &C.
## South Wilbraham, Mass.

Marcus Beebe's business card, advertising his wares, is similar to those issued today. A native of the town, he acquired an excellent reputation as manufacturer of the plows and wheelbarrows that were sold in several towns.

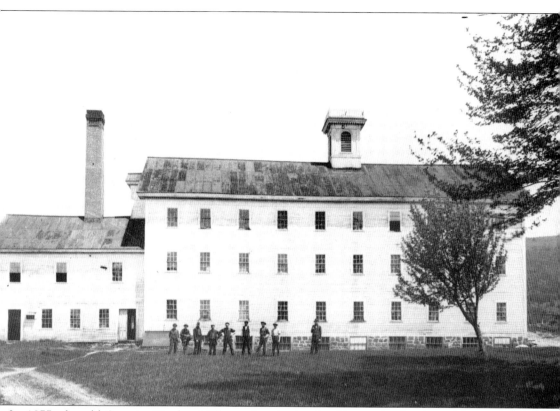

In 1877, the old Scantic Woolen Mill was bought by the Kenworthy family and became the Kenworthy Mill, makers of blankets and yarn. The family lived in town, and their children were students at Hampden schools. (Howes Brothers Photos, courtesy of the Ashfield Historical Society.)

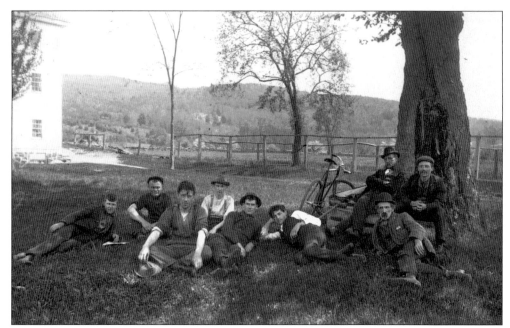

In 1901, these workers are taking a well-earned rest on the grass beside the mill. The bicycle in back was probably ridden to work by a mill hand. Note the makeshift bench encircling the tree. (Howes Brothers Photos, courtesy of the Ashfield Historical Society.)

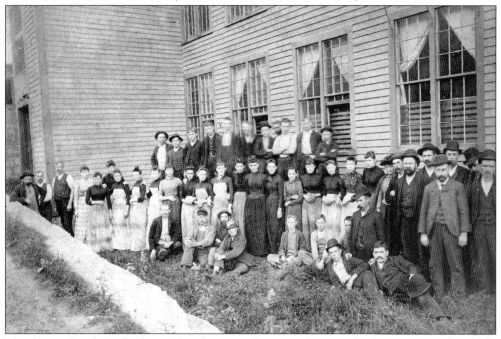

The former South Wilbraham Manufacturing Company became the Lacousic Woolen Mill. This photograph shows some of the workers gathered outside. The mill had 16 looms and 5 sets of machinery, turning out about 16,000 yards of fancy cassimere (medium-weight soft woolen cloth) per month. Note the variety of the men's headgear and the aprons worn by the women. (Howes Brothers Photos, courtesy of the Ashfield Historical Society.)

The west side boardinghouse was one of three in town that served as homes for the mill workers. With three shifts working at the mill, the beds had no chance to get cold, for as soon as one man got up, another tired worker was ready to drop into his place. The large garden probably provided laborers with vegetables.

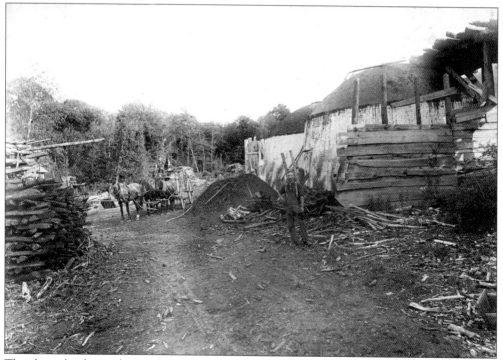

This busy lumberyard was owned by the Thresher Brothers. The roof on the shed kept the planks dry. In the background, a team of horses is pulling a heavily laden wagon piled high with lumber.

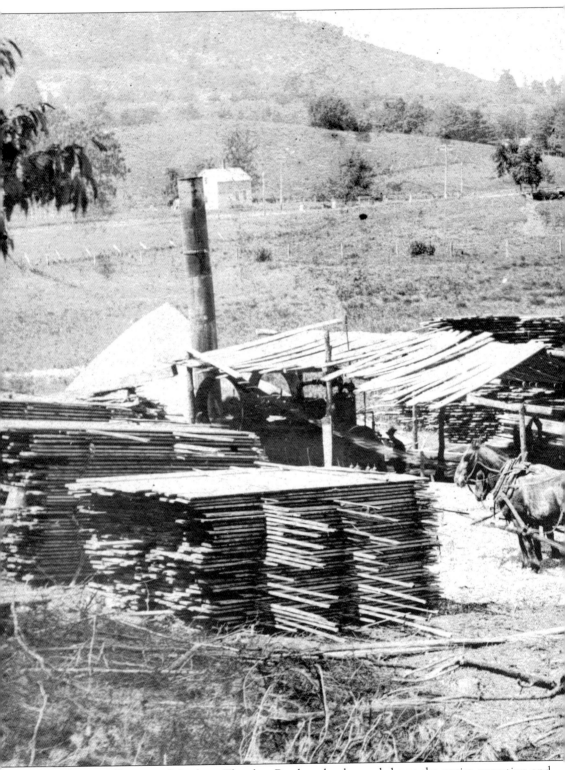

This overall image of the busy Thresher Brothers lumberyard shows the entire operation and

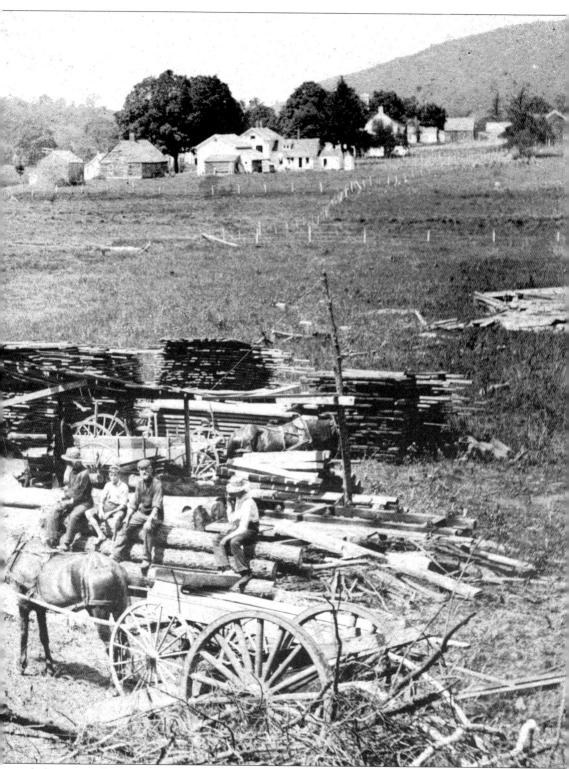

includes an excellent view of the farms in the distance. Teams of horses were kept busy.

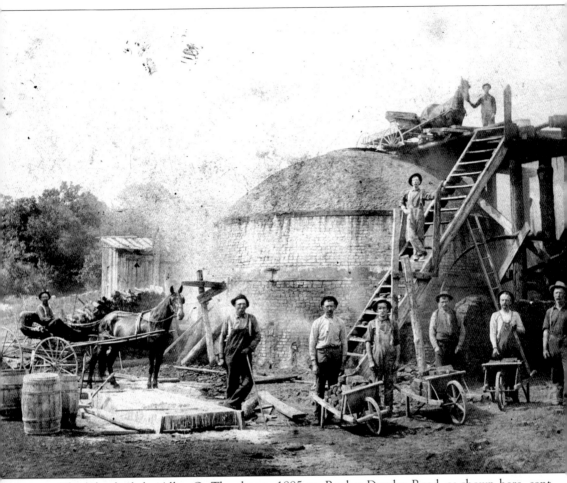

The kilns built by Allen O. Thresher c. 1885 on Rock-a-Dundee Road, as shown here, sent clouds of smoke aloft, a sign that soon wagons of charcoal would wend their way to his largest customers—the Springfield Armory and the Hazard Powder Company (Hazardville, Connecticut). Each month, some 4,000 bushels of charcoal were produced and delivered to customers. These kilns are probably being repaired, as the mortar bed and wheelbarrows are evident.

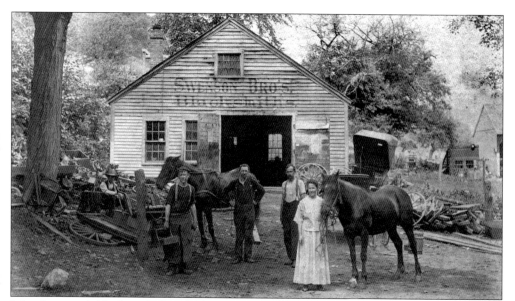

John Swenson's blacksmith shop had previously been owned by Joseph W. Stimson and then by Charles W. Twist. John Swenson was the first chief and "father" of the Hampden Volunteer Fire Department. In 1925, he built the body for the first fire truck out of a $75 Cadillac chassis with the help of Fred A. Perkins, Arthur H. Gerrish, Austin K. Harris, Leroy O. Howlett, and others. The truck carried ladders, pails, brooms, a hose, and a portable pump. It held 100 gallons of water. In this view, John Swenson poses with family members.

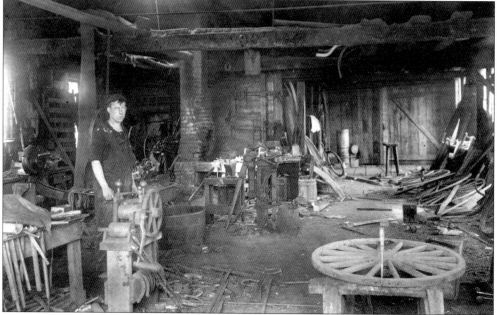

Morris Ackland, 16, nephew of John Swenson, is shown in the interior of the blacksmith shop c. 1909. This photograph was taken just after the huge bellows had been replaced with a modern circular hand fan. At the right-hand window is a frame to be let down onto a horse, the straps going under the horse's belly, to lift him off his feet. This blacksmith shop was on Main Street, west of the entrance to the Hampden Memorial Park, and was later torn down.

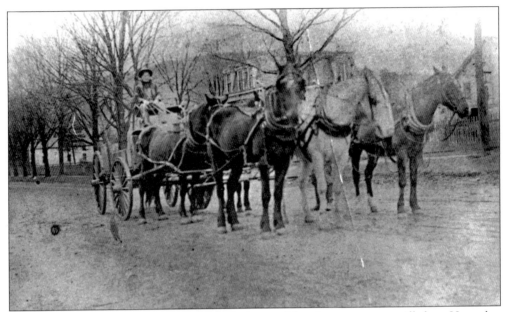

The Hampden Express, with driver Frank Taylor, used four horses to carry milk from Hampden to Springfield in 1900. It was necessary to take along a fifth horse to help with the pulling when mud was deep, especially by Christianson's Swamp on East Longmeadow Road and going through the mudholes on Springfield Road.

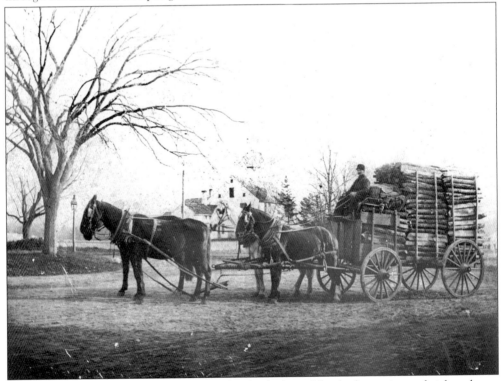

Early in the morning, Albert Lee set off with a load of wood for the long trip to a brickyard near Springfield's Forest Park. To the left of the horses, note the post holding a lamp.

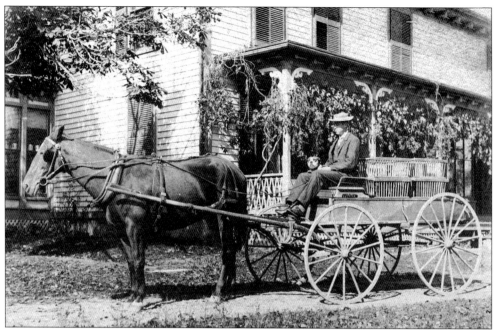

Hunt's Grocery Store was located at the corner of Main Street and Chapin Road, a site occupied by other stores at various times. Here, Bill McCray waits outside. Note the fashionably bedecked porch behind him, replete with hanging plants.

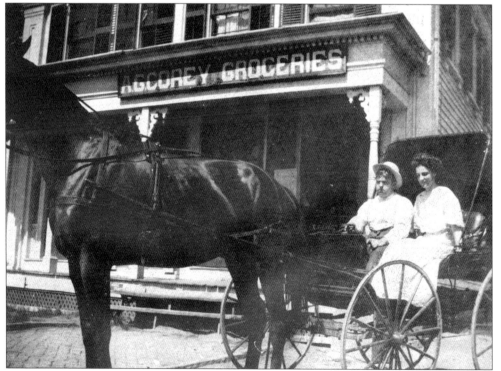

In 1913, Mr. and Mrs. A.G. Corey were owners of the grocery store at the corner of Main Street and Chapin Road. In this view, they are starting out for a ride in a large-wheeled carriage.

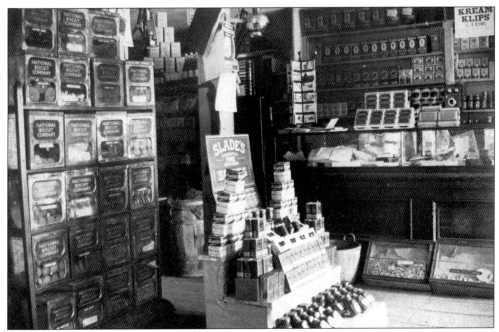

This interior view of A.G. Corey Groceries in 1918 shows the popular food of the time, with many bins holding cookies and crackers made by the National Biscuit Company. The overhead lantern provided light on a dark day. Does anyone remember Kream Klips?

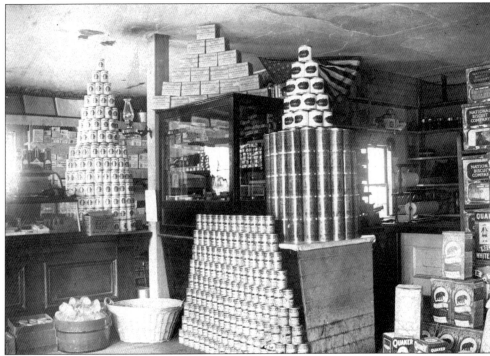

Another section of the grocery store shows that someone had a steady hand when stacking cans. Do you suppose any child was ever tempted to knock them down? Quaker Oats products are evident. A flag or banner is attached to the ceiling behind the cans.

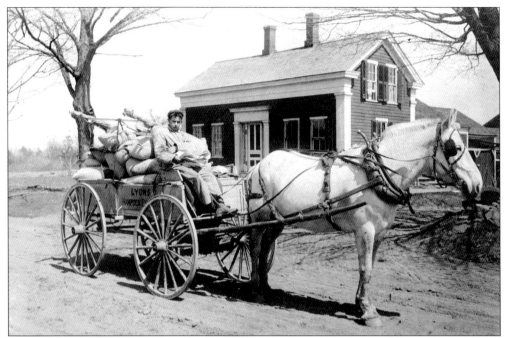

In 1912, Walter Lyons was the driver for Lyons Express of Hampden. This photograph was taken in East Longmeadow across from Chestnut Street. Lyons's wagon is loaded with large bags, probably containing feed and grain.

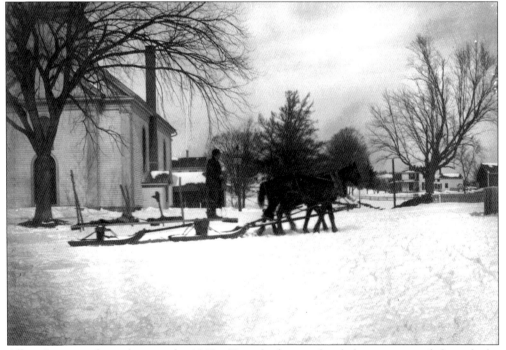

Albert Lee was always busy in the 1900s. Here, he has used a sled to carry wood through the snow, has made the delivery, and is now heading for his home. The view shows Main Street as it appeared years ago.

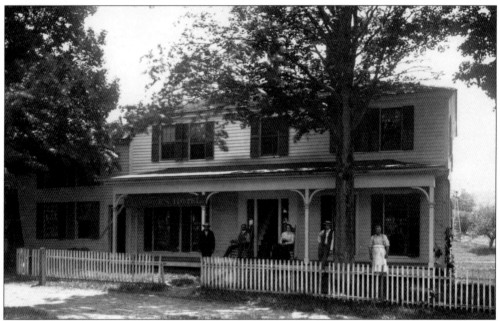

In 1807, Elizur Tillotson Jr. welcomed travelers with good food, drink, and lodging for the night. After he sold out in 1812, the building passed through several hands and was the home of a young married couple, Caroline Saxton and Alford Cooley, in 1833. In 1860, it was sold to William P. Chaffee, the large sign indicating it is Chaffee's Hotel. Guests rock contentedly on the porch. The hotel was sold to the Thresher family in 1906. (Howes Brothers Photos, courtesy of the Ashfield Historical Society.)

This is the old mill on Norman Chaffee's place at the Wesson Farm, probably no longer in use. Arthur Jones sits on the mill. His mother, granddaughter of Norman Chaffee, stands below.

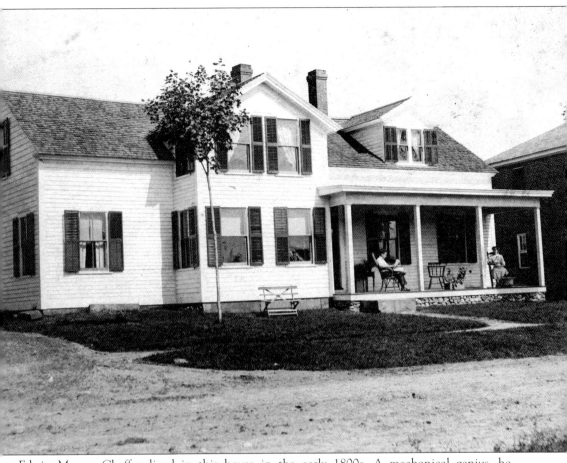

Edwin Marcus Chaffee lived in this house in the early 1800s. A mechanical genius, he experimented with rubber for years, hoping to find a way to make it pliable for the production of boots and clothing. One wintry day, a batch of rubber cooking on the stove boiled over, sending an obnoxious stench through his home. He grabbed the pot off the range, hurried outdoors, and tossed it onto the snow. In the morning, when he lifted the remains, he found the rubber had become elastic and pliable. On August 31, 1836, a patent was granted to him for his process that made it possible to apply rubber to clothing and other articles. He started the Roxbury Rubber Company, the first of its kind in this nation, and later sold the patent to Charles Goodyear.

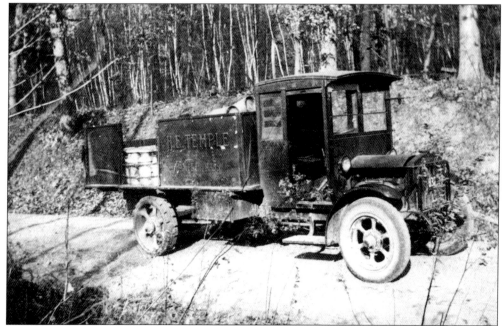

Harry Temple carried milk *c.* 1922 from Hampden to the Somers Creamery in this 1921 White truck. Note the large front wheels in comparison with those in the back. With the state of the roads in those days, we wonder if traveling over ruts ever made the cream that Temple might have carried turn into butter?

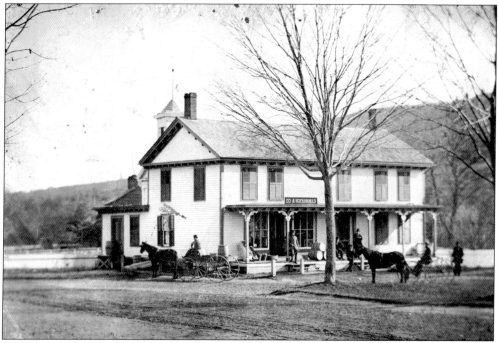

This photograph of the Charles I. Burleigh store was made from an old tintype in which his name was reversed. Many different proprietors operated a store here. The porch was a fine meeting place for chatting with friends.

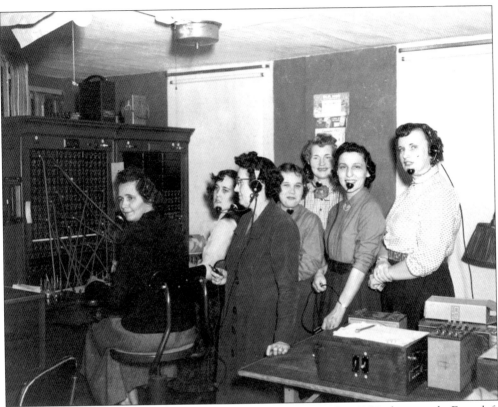

Operators of Hampden's telephone switchboard are shown in this 1953 photograph. From left to right are Frances Flynn Howlett, Helen Pandolfi, Esther Ackerman Edwards, Patricia Fiske, Winifred Prichett, Lily R. Prichett, and Vera Maxwell.

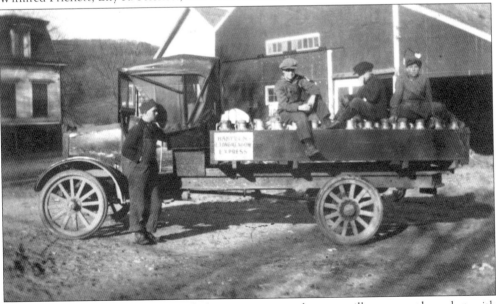

In this 1916 photograph, unidentified young men perch atop milk cans as they chat with the driver.

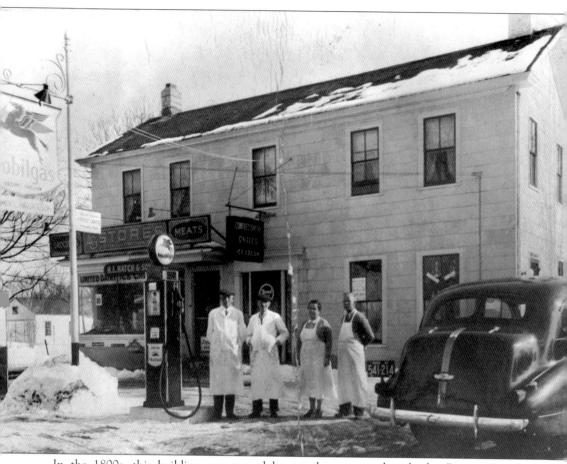

In the 1800s, this building was owned by people connected with the Boston & Albany Railroad. Changing owners several times, it was remodeled into a general store by Harry E. Temple. Charles Spencer made delicious candy that he sold here in addition to running the post office in the west front room. Homer L. Hatch bought the property in 1933. The family operated the store until 1968. Pictured, from left to right, are George Murdough, Fred Letellier, Dorothy Hatch Gulbrandson, and Homer L. Hatch. Note the "flying red horse" on the large sign and on the old-fashioned gas pumps. United Dairy ice cream was carried here.

*Three*

# CHURCHES

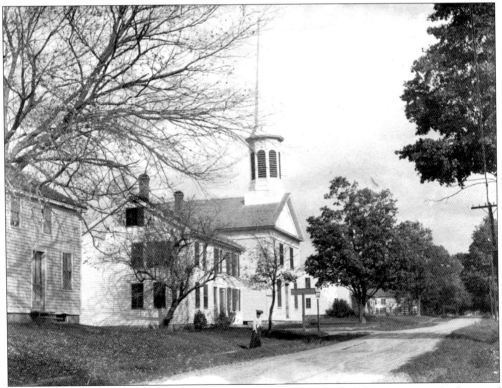

This scene on Main Street shows the Ackerman house to the left. Next to it is the home of W.M. Pease, which later burned. The Baptist church can also be seen. The beautiful steeple was once a landmark in town and could be viewed from many places in the village. The sign points toward the store in the vestry.

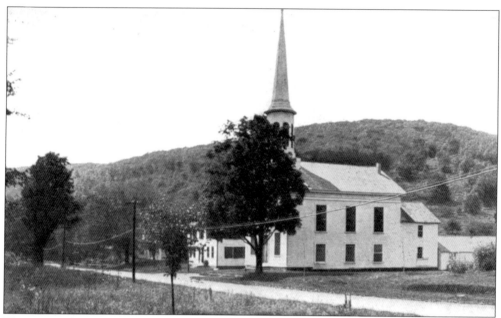

This postcard view of the Baptist church shows its spire. A typical white New England church, it lent charm to the village.

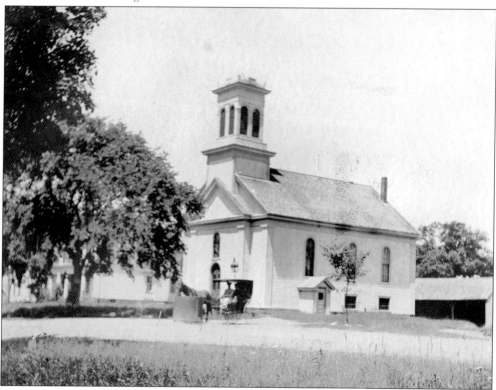

In this view of the Congregational church, note the horse and carriage containing worshipers. Horses stayed safe from the elements during the service in the sheds behind the church. The barrel in front provided horses with water.

This is the wife of the Congregational pastor Rev. George W. Solley, who served from 1894 to 1896. Perhaps this photograph was taken inside the parsonage. The ornate picture frames lend a feeling of luxury to the décor of the home.

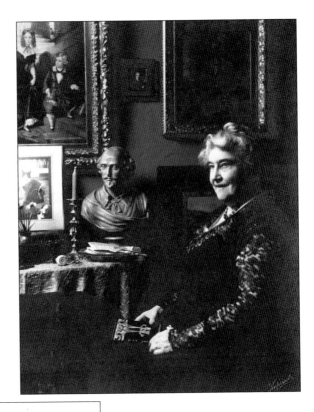

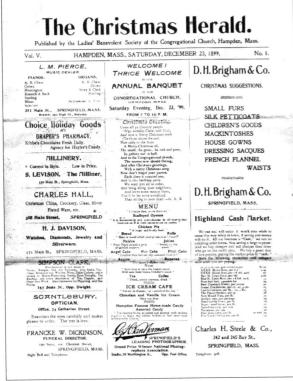

This is volume five of the *Christmas Herald*, put out by the Ladies Aid Society on December 23, 1899. The menu for the society's annual banquet included scalloped oysters, chicken pie, bread, rolls, pickles, jellies, angel cake, nut cake, fruitcake, apples, bananas, nuts, tea, coffee, chocolate and vanilla ice cream, and Hampden's famous homemade candy, "the candied fruits, so called and spotted with molten sugar as to make the coldest lookers-on feel faint—and subsequently bilious."

43

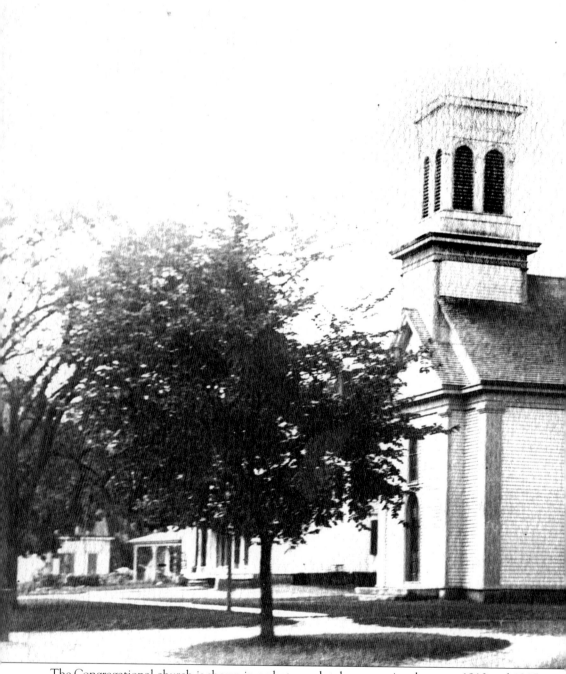

The Congregational church is shown in a photograph taken sometime between 1910 and 1915. William King's house originally stood here. It was moved to make way for the church, which was transferred to this spot from the village green in 1838. The original sanctuary was a rough structure of unpainted boards, built in 1783. Unfortunately, just after being redecorated for use

as a federated church, the building shown here burned on Saturday evening, January 26, 1924, and was never rebuilt. The weather was so cold that ice on the Scantic River had to be chopped so that water could be secured to extinguish the flames.

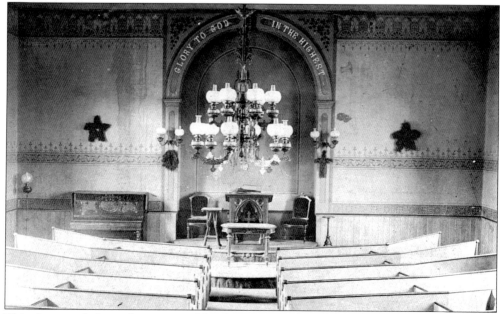

This photograph shows the interior of the Congregational church in 1901. Note the glass globes on the chandelier and the rounded pews of the congregation, slanting so that each is as close to the ornate pulpit as possible.

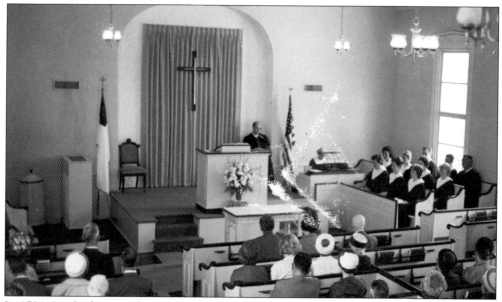

In 1791, Methodist preachers came every two weeks, conducting services in Abner Chapin's kitchen on Somers Road. Later they met in the West Side School. The Methodist Episcopal church was built on North Road in 1830. In 1858, once a parsonage had been erected and the costs paid, the Methodist church was moved on rollers down the hill from North Road to its present site. The former back of the church is now its front. The building later became the Federated Community Church of Hampden. The interior of the church is shown as it looked before the choir loft was moved to face the congregation. Rev. Robert Van Gorder is the minister in this photograph.

This is the pulpit that once rested in the sanctuary of the Federated Community Church of Hampden. It was too large and ornate for the simple décor of this old New England place of worship. The father of Rev. Robert Van Gorder gave the church the pulpit it has now, which is more in keeping with the church's simplicity.

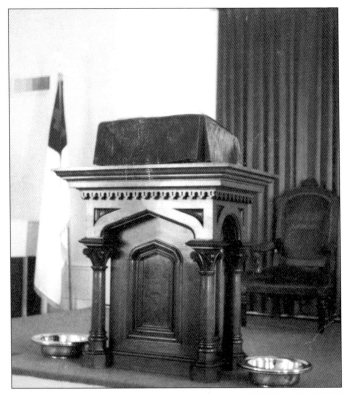

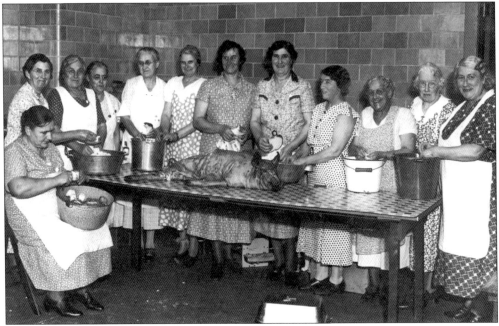

These members of the Ladies Aid Society are preparing a roast-pig-and-chicken-pie supper in the new town house kitchen. From left to right are Emma Ackerman, Lyda Temple, ? Mason, Edna Isham, ? Ferguson, Kenia Carew Ryder, Ruby Hooker, Elizabeth Perkins, Ethel Roux, Mabel Fisher, ? Millard, and Margaret Joyce. (Photo courtesy Springfield Newspapers.)

Rev. Ezekiel Russell, D.D., born in Hampden in 1805, did not pastor a church here but was a student of Hampden's first minister, Rev. Moses Warren. Russell became pastor of the Olivet Congregational Church in Springfield.

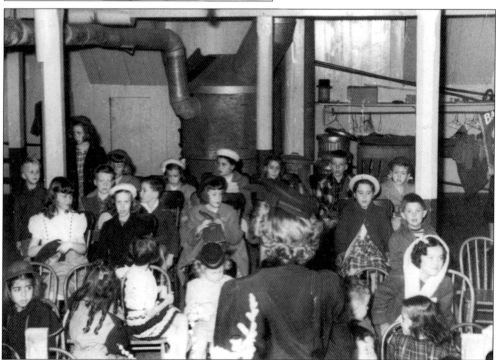

This image shows the Sunday school area at the Federated Community Church of Hampden at the time when the unsightly boiler that provided heat was prominent. A fence was put around it to protect the children, and a program was launched to redo the vestry.

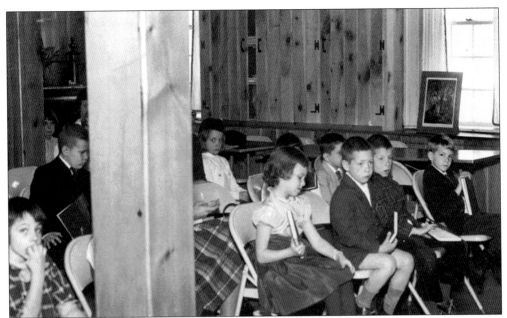

After a successful effort to revamp the vestry, the children met here for worship services. The vestry was used for a variety of functions, from Sunday school classes to wedding receptions.

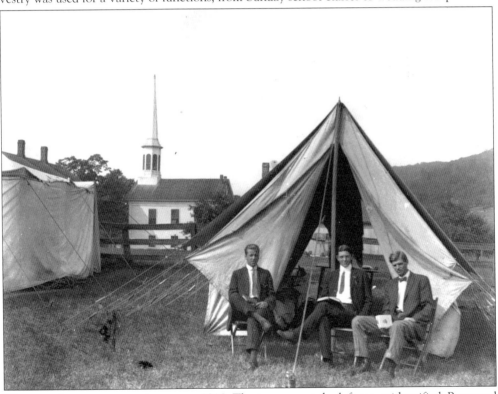

This gospel tent was set up in town *c.* 1918. The two men at the left are unidentified. Reverend Jacobson (far right) later became a minister of the Methodist church. The Baptist church is in the background.

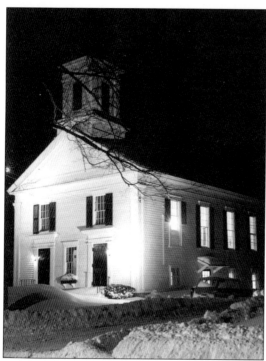

The Federated Community Church of Hampden, lit for an evening service, sends a warm glow across the snowbanks in this wintry scene.

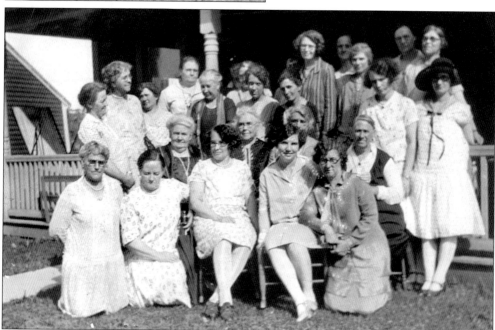

The Ladies Aid Society poses in 1928. From left to right are the following: (front row) Edna Fisher, Gerta Larson, Lillian Moody, Anna Burleigh Booker, and Pauline Young; (middle row) Maria Burleigh, Mrs. Lucien Guptil, Minnie Fraser, and Dorothy Morse; (back row) Sara Thomas, Mina Sessions, Bessie Thresher, May Hatch, Mrs. George Ferguson, Edna Isham (in back), Violet Gottsche, Lyda Temple, Nancy Libby, Mrs. Walter Bartlett, Kenia Carew, Hazel Fisher, Mrs. Leonard Wilmot, Bertha Medicke, and Louise Burleigh Davis.

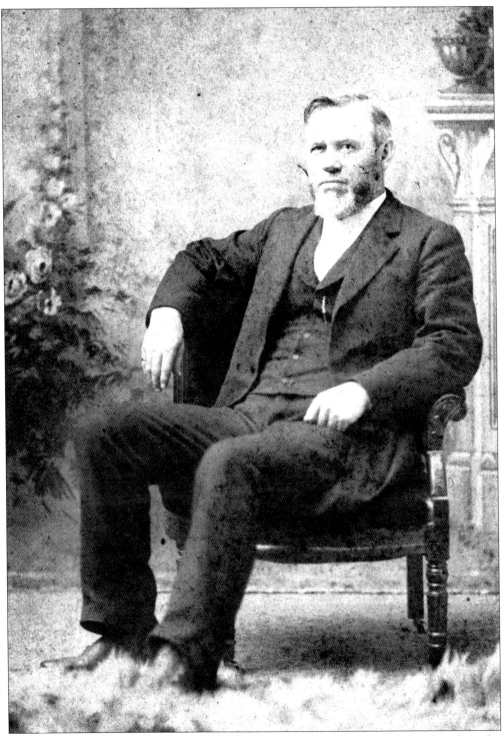

Rev. Calvin Stebbins is shown c. 1895. The Baptist and Congregational churches formed a federation in 1914. In 1916, the Methodist church joined the federation. Later on, the Baptist church withdrew from the federation. Stebbins was married in Hampden to Lucinda Beebe.

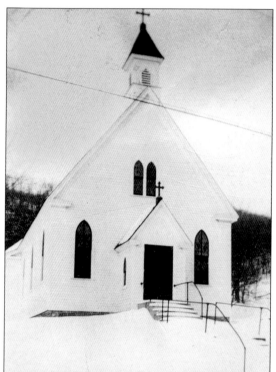

In 1881, the first St. Mary's Church of Hampden was built as a mission church of St. Patrick's in Monson. Every other week (or if the weather permitted), the priests of Monson traveled the winding, mountainous dirt road to Hampden to say Mass or baptize children. Oil lamps provided illumination. The church was heated by wood. It was razed when the new St. Mary's was built on Somers Road.

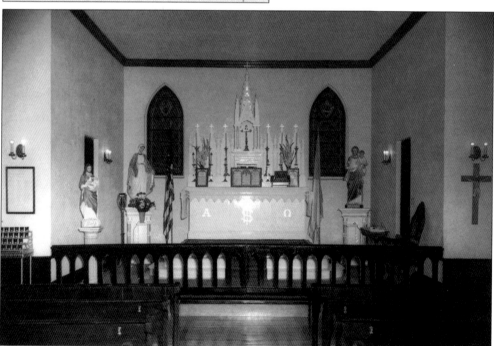

The interior of the old St. Mary's is shown here. In 1934, the Catholic Women's Club was formed and raised funds to purchase necessities, such as linens and candlesticks. The ladies worked hard to finance improvements and repairs. Once the church was wired for electricity in 1938, evening services could be held.

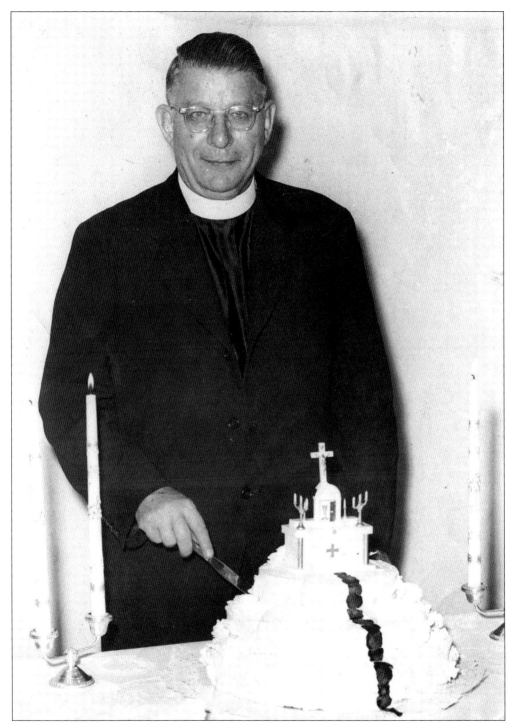

In 1951, Fr. John Shea was appointed by Bishop Christopher Weldon to be St. Mary's first full-time priest. St. Mary's was no longer a mission church. In this view, Shea cuts the cake on the 30th anniversary of his ordination. He received his grammar school and high school education in Holyoke.

The first confirmation class at St. Mary's is shown here with Fr. John Shea. From left to right are the following: (first row) Romeo St. Pierre, Frances Claing, William Bernard, Robert Witkop, Roland Cote, Josephine Witkop, Jeanette Witkop, Joan Terzi, and Carol Claing; (second row) Robert Rogers, Richard Howlett, Stanley Witkop, Francis Bernard, Pauline Coderre, Patricia Barry, Noella LaBelle, and Mary Lou Heroux; (third row) Roland Baribeau,

Robert Labodycz, James Meade, Phillip Tracy, John F. Moriarty Jr., Ralph Butler, Elaine Sloat, Marilyn Lyons, Jane Duffy, Kitty Connors, Marion LaBelle, Priscilla Attleton, and Sally Ann Witkop; (fourth row) Dorothy Niquette, Rosalie Meade, and Patricia Connors. (Photo courtesy Springfield Newspapers.)

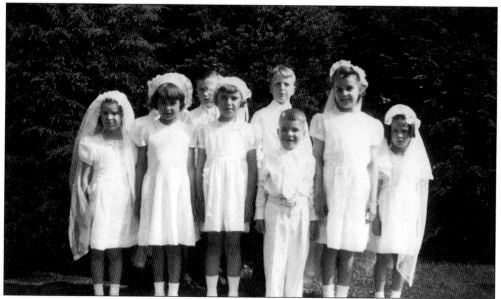

These unidentified children pose happily on the day they made their first communion.

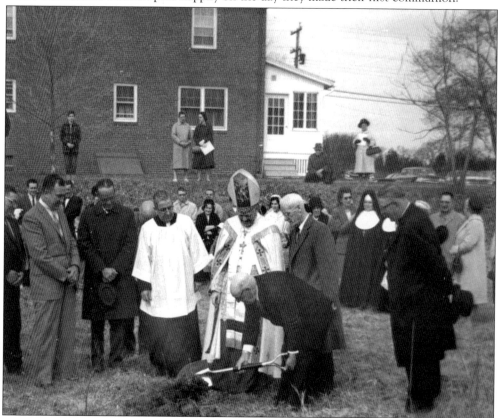

Parishioners and clergy are shown in 1963 at the time of the groundbreaking for the new church to be built on Somers Road. Bishop Christopher Weldon visited, turning the soil with a gilded spade. Soon, the new parish center was constructed.

*Four*

# SCHOOLS

Eleanor Burleigh taught this class of youngsters in the 1920s. Among them are Frances Flynn, Rosie Bandoski, John Lyons, Harold Corey, and Barbara Fowler. Unfortunately, there is no indication of the names of the other children.

The first Center School burned *c*. 1913, when a fire started in a woodpile inside the two-room building. It was the custom then for young girls to wear pinafores to school to keep their dresses clean. One teacher taught students of various ages.

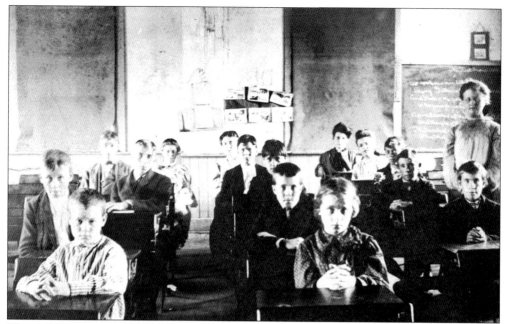

The children shown in this interior view are, from left to right, Gus Higgins, Neil Kibbe, Henry Warren, William McCray, Lena McCray, Alice Brennan, John McKenna, Spencer Davis, Walker Holmes, Ida Warren, Raymond Burleigh, Charles Burleigh, Robert Ballard, Nettie Pease, and Bessie Brennan. The teacher is unidentified.

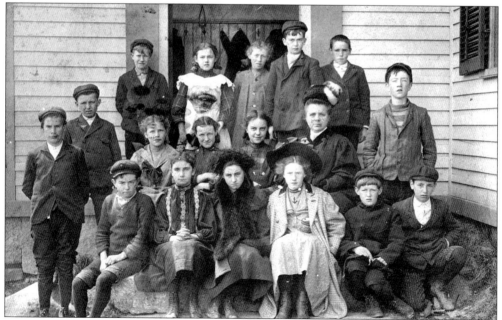

These pupils are posing on a cool day. From left to right are the following: (front row) Ray Burleigh, Walter Lyons, Louise Burleigh, Mary Brennan, Helen Kibbe, Harold Ball, and Angelo Willard; (middle row) unidentified, Gladys Pease, Arline Howlett, Mabel Davis, ? Small, and Raymond Dunlea; (back row) Russell Kibbe, Dorothy Kenworthy, Ruth Kibbe, Cliff Bradway, and unidentified. Notice the large hats worn by two of the girls.

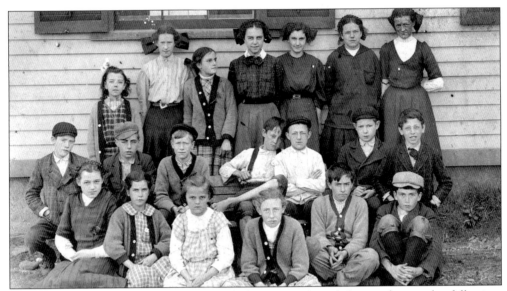

Hampden children pose outside their school *c.* 1910. From left to right are the following: (front row) Dorothy Kenworthy, Esther Burleigh, Grace Soper, Ruth Kibbe, Walter Lyons, and Clifford Bradway; (middle row) Michael Murphy, Ralph Lyons, Russell Kibbe, Ralph Mayor, Salvador de La Pata, Louis Rosenberg, and Abraham Cohen; (back row) Madeline Kenworthy, Helen Kibbe, Eleanor Burleigh, Mabel Davis, Louise Burleigh, Gladys Pease, and Arline M. Howlett.

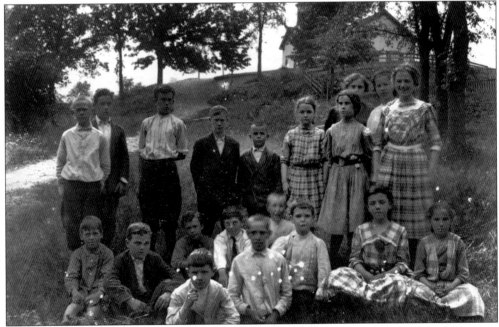

This image shows children of the Center School *c.* 1911. From left to right are the following: (first row) unidentified, Harry Lyons, and Carl Howlett; (second row) Albert Weeks, three unidentified students, Earl Howlett, Madeline Kenworthy, and Anna Burleigh; (third row) three unidentified students, Russell Kibbe, unidentified, Gertrude Lyons, Esther Burleigh, and Dorothy Kenworthy; (fourth row) Eleanor Burleigh and Annie Linnehan.

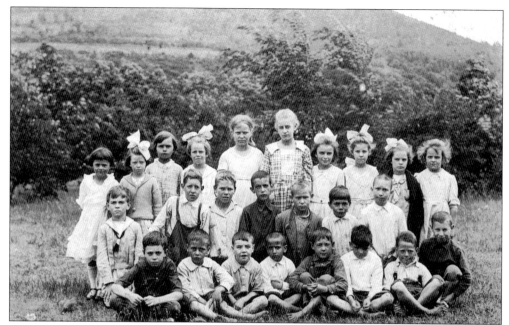

A class from the two-room Center School on North Road is shown in the late 1920s or early 1930s. Hair bows (the bigger the better) were a fashion must for the girls. Those were the days when boys with bare feet could attend school. There was no dress code and no rivalry as to clothing.

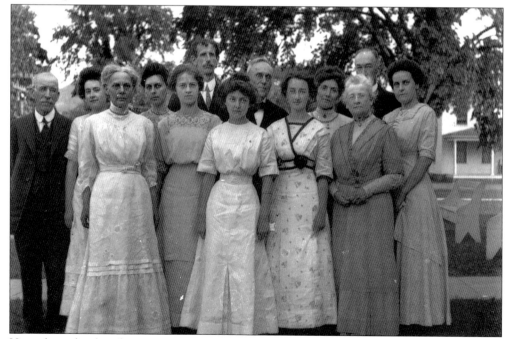

Hampden schoolteachers pose in 1912. From left to right are two unidentified people, Alice May, ? Dimmock, ? Smith, Reverend Charles B. Bliss, unidentified, Deacon Newell, ? Faye, ? Hooper, ? Poland, Marcus Beebe, and unidentified. The dresses were beautiful, with tiny waists emphasized. Note the suits and ties donned by the men.

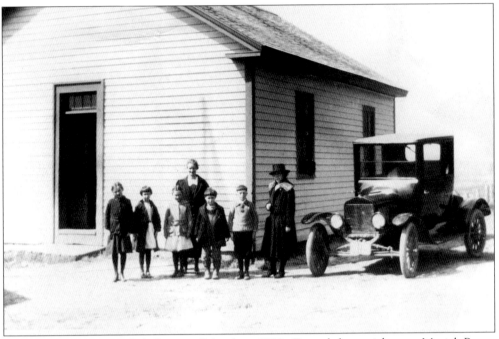

These youngsters attended Scantic School *c.* 1922. From left to right are Muriel Pease, Madeline Gunther, Rachel Pease, Reginald Temple, and Clifford Gunther. The adults are unidentified. The automobile probably belonged to a teacher.

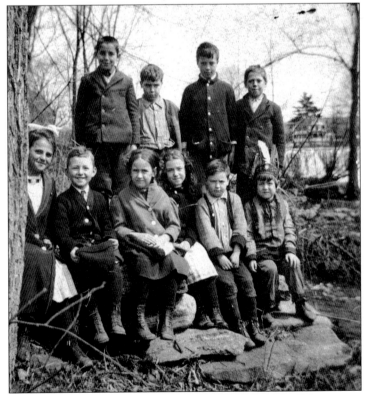

This class enjoyed recess outdoors beyond the temporary building where they were housed after their school burned. From left to right are the following: (front row) Etta Soper, Carl Gottsche, Frances Stockton, Leonice Kenworthy, James Lyons, and Jack Stockton; (back row) unidentified, Louis Lyons, unidentified, and Walter Lyons.

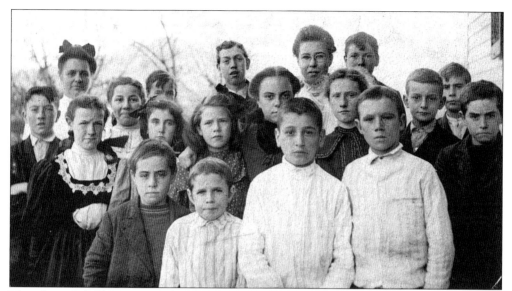

This class of children was taught by a Miss Small. From left to right are the following: (front row) Ralph Lyons, James McKenna, Angelo Willard, Augustine Higgins, and Walter Lyons; (middle row) Arline Howlett, Louise Burleigh, Gladys Pease, Mabel Davis, Helen Kibbe, and William V. Sessions; (back row) Raymond Dunlea, Grace Perry, Elmer Smith, Robert Ballard, Lena McCray, Walker Beebe Holmes, and Raymond Burleigh.

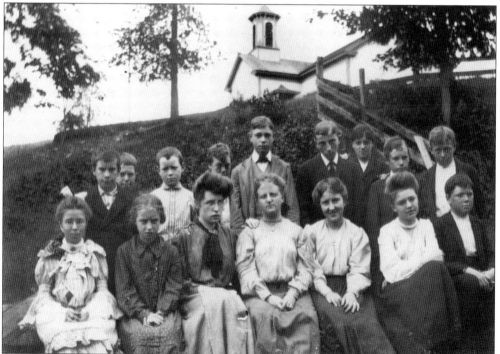

These older students pose below the Center School c. 1908. From left to right are the following: (front row) Lena McCray, Alice Brennan, Bessie Brennan, unidentified, Ida Warren, Nettie Pease, and Walker Homes; (back row) Raymond Burleigh, five unidentified students, Charles Beebe, unidentified, Charles Burleigh, and unidentified.

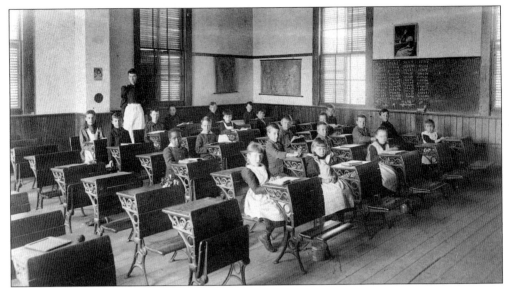

This picture shows the interior of the second Center School, which was built in 1913 after the first one burned. The older students may have removed themselves so the little ones could have their picture taken. The desks had inkwells and room for books. Boys sometimes dipped girls' braids in the inkwell to turn blond hair green.

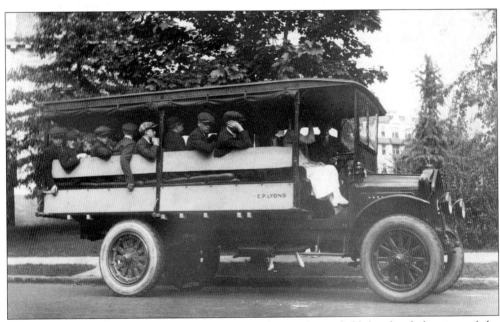

In 1922, this school bus took children of Hampden to Springfield for the dedication of the Memorial Bridge. Harry Lyons is driving the bus, and Gertrude Lyons sits beside him, wearing a white dress. The caps worn by the boys are quite different from the baseball caps of today.

## Five
# HOUSES AND FARMING

Annie Newell is drawing water from her well beside her house on Glendale Road. Note the large milk cans on the ground beside her.

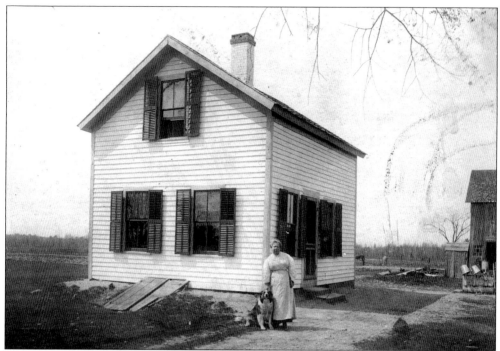

Julia O'Brien, standing in front of her house on East Longmeadow Road, lived here for about 70 years. Pails hang tidily on her barn.

In 1935, this is the way the big barn at the old Kellogg farm looked. Located at 300 Wilbraham Road, it was torn down for taxes soon after this picture was taken.

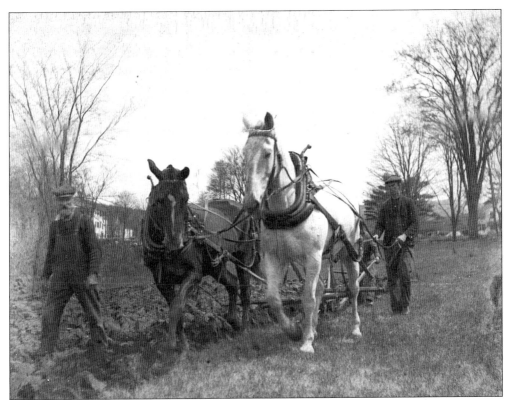

This early-1900s photograph shows Charles Henry Burleigh (left) and Walter Beebe on lower South Road near the bridge over the Scantic River. The horses, Mag and Bill, belonged to Edward Lyons. The person holding the handle of the plow is unidentified.

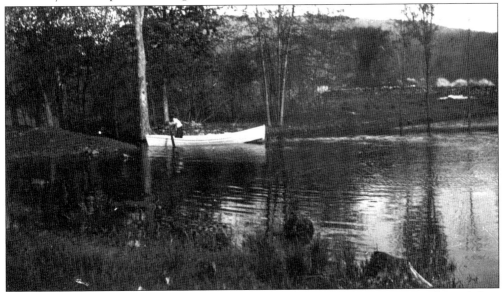

Do you recognize this beautiful pond with its clear, cool waters, as the one on Mill Road? It is no longer as large as in this photograph because of the growing vegetation. Harold Woodworth maneuvers the boat on this, his grandfather's farm.

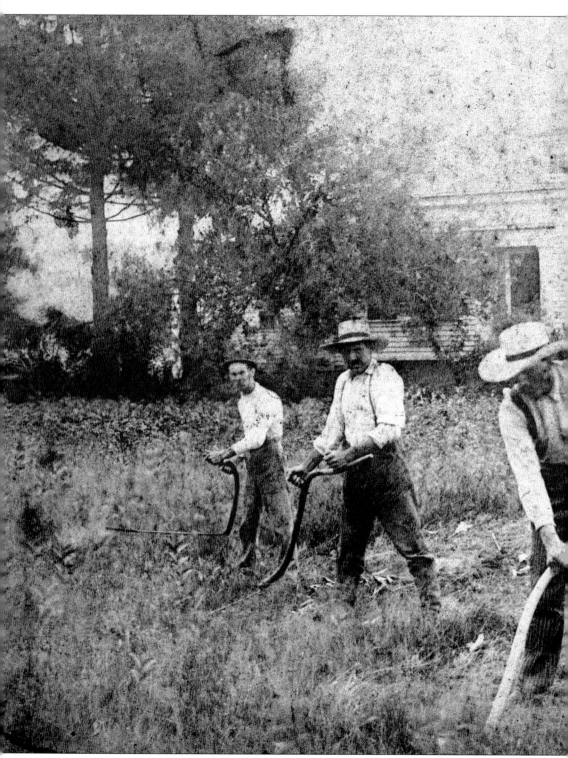

Mowing the field by hand are, from left to right, Erwin Temple, Homer Pease, and Clarence West. The boys raking the hay are Lucius Temple, Walter Temple, and Raymond Pease. In this

backbreaking manner, men mowed meadows long before tractors made the job easier. The house belonged to Clarence West.

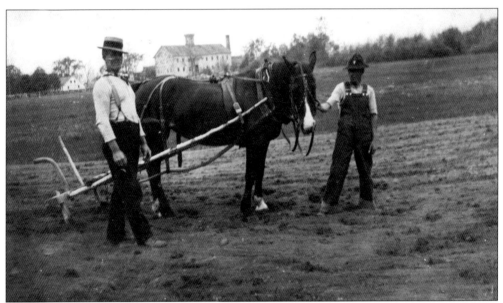

Thomas Woodworth (left) and James Miller are shown on Somers Road. The large building in the background is the Kenworthy Mill, which specialized in making yarn and blankets.

The Mortimer Pease House, on Somers Road, is bedecked with the American flag either for the Fourth of July or Decoration Day. Note the vines growing up the pillars and the array of potted plants on the porch.

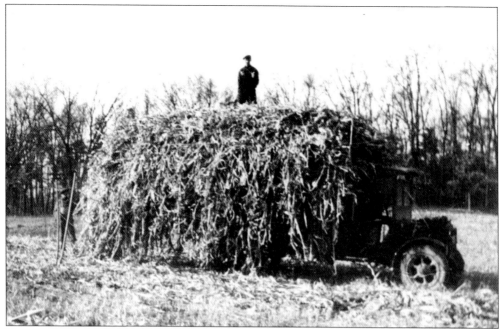

Harry E. Temple's milk truck is being used as a hay wagon in this 1923 scene at the Temple Farm on Scantic Road.

This 1893 photograph shows Elizabeth Brennan's home, opposite the old St. Mary's. Pictured, from left to right, are Mary Lyons, Raymond Dunlea, and Elizabeth Brennan. Note the porch shaded by vines.

In 1793, Luther King owned this land on North Road. It is felt that at least a portion of this house was built by Sumner Sessions, who built the Lacousic Woolen Mill. When he died, his property was inherited by his daughter Harriet Sessions, who was a professor at Mount Holyoke College. When Harriet Sessions died, the home became that of her cousin Elizabeth Sessions, who gave Hampden its town house and who made the grounds here beautiful with many varieties of flowers and shrubs. She spent the rest of her life here.

Both the telephone exchange and the town clerk's office were once housed in this building. When the Baptist church burned in 1932, this structure also caught fire and was destroyed. (Howes Brothers Photos, courtesy of the Ashfield Historical Society.)

This 1934 photograph shows the home and store of Corwin L. "Fish" Kibbe, who sold his fish, canned goods, and vegetables in other towns as well. The author remembers his coming with his wares to her grandmother's farm in East Longmeadow.

This house was built by Patrick McCarthy *c.* 1872. He maintained a store in its basement. It was torn down *c.* 1980 when Main Street was reconstructed. (Howes Brothers Photos, courtesy of the Ashfield Historical Society.)

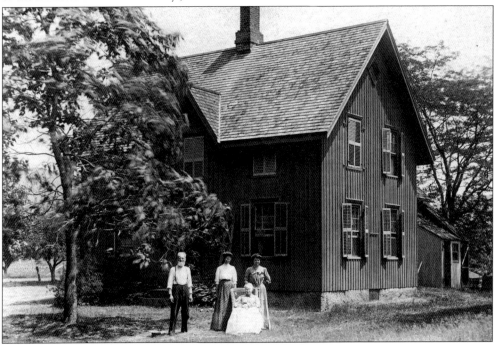

This house on Somers Road was built *c.* 1840 by Ralph Sumner Chapin, who married that year. Factory-made nails are used in its construction. This photograph was taken in the early 1900s, when William Leach owned the house. Shown, from left to right, are William Leach, Elizabeth Leach Woodworth, Annie Irish, and Abigail Leach.

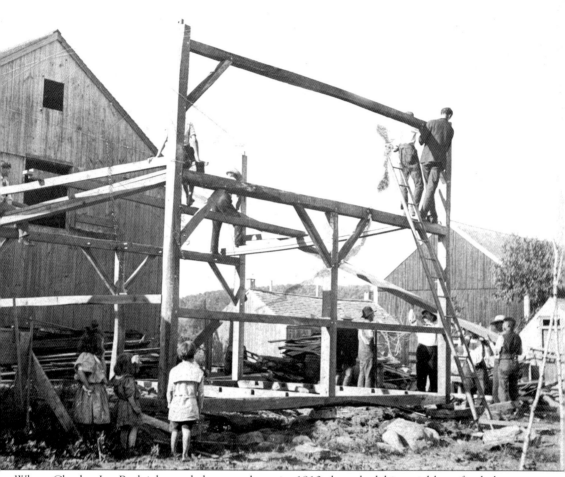

When Charles Ira Burleigh needed a new barn in 1910, he asked his neighbors for help, planning to repay them in the same fashion. Imagine the pounding of hammers, the low tones of the men calling back and forth, and the childish laughter. The three children, from left to right, Gertrude Lyons, Hazel Thresher, and Ed Burleigh, watch, fascinated, as the men put together the rafters for the new edifice. An unidentified man and Frank Perry talk with Charles I. Burleigh (far right). Also in the photograph are Henry Warren and Rev. Charles Bliss.

In 1870, this house was built as far as possible from the original house at 218 East Longmeadow Road. The original one had burned, thus wiping out (according to its builder, Edmond Speight) the diphtheria that had caused the deaths of two Speight children. The shutters are no longer on the house, and the barn was razed a few years ago. However, the stone steps at the side entrance of the house still stand, as in this picture. The unidentified woman and boy are presumed to be members of the Speight family.

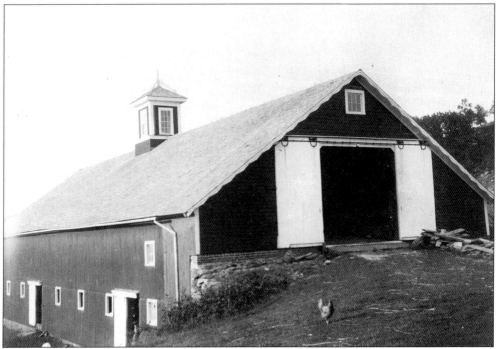

Erected in 1875, the Sessions barn was 100 feet long, with room for a large herd of cows. It was built into a bank of earth at one end, providing easy access to both the bottom and second floor of the barn, a smart New England way of planning.

This house is believed to have been constructed by a member of the Stebbins family *c.* 1800. John C. Stebbins sold the property to Edward Wall in 1875. Patrick E. Wall (at one time chairman of the selectmen and superintendent of the Lacousic Woolen Mill) lived here, as did his daughter Mary Wall Haley and her family. The Sicbaldi family purchased it in 1936. Pat Wall is shown here with his dog.

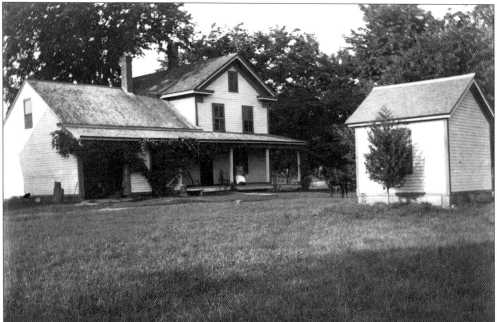

Rev. Rufus P. Stebbins, who was one of the founders of the American Unitarian Church in this country, was born in this house, which must have been built by a member of the Stebbins family. Eventually, this farm was owned by Orville Pease and, later, by his son Mortimer Pease, a Civil War veteran who operated a shoddy mill with his father.

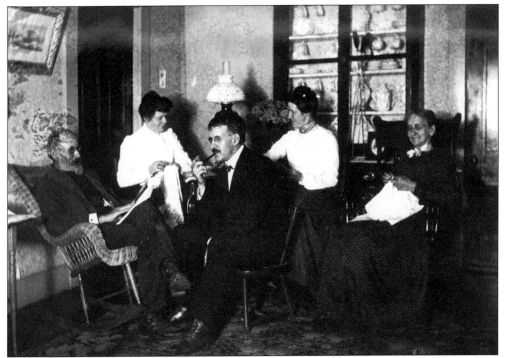

This cozy scene shows the Mortimer Pease family at leisure inside their home. From left to right are Mortimer Pease, daughter Grace Pease (who later married Nelson M. Carew), son Durrell "Dewey" Pease and his wife, and Mortimer Pease's wife.

In 1769, John Chaffee deeded this land on South Monson Road to his son Amos Chaffee. Several people owned the land thereafter. It is thought that either Joshua Stanton Jr. or his father built this house, which was almost out of sight when viewed from the road. The long porch covered two sides of the house. The porch in the front was eventually screened and made into a delightful spot to sit and read. Another section was enclosed and featured a huge stone fireplace, perfect for taking away the chill on a fall day. Esther and Waldo Griggs, pictured above, spent many happy hours here. In later years the house was razed.

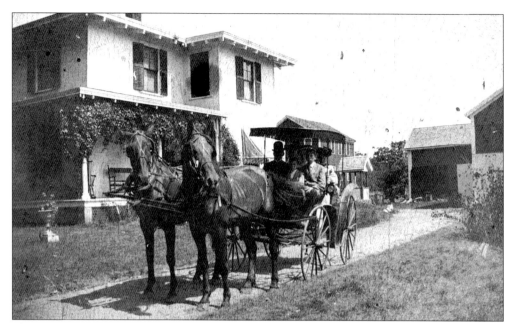

The Warren House, located at 20 North Road, is pictured here. The house was lived in by Moses H. Warren, grandson of Rev. Moses Warren, Hampden's first minister. Moses H. Warren was one of the leading dairy farmers in town and spent his married life here. When he died, the property went to his son Fred A. Warren (a state representative), who was born here in 1857. Shown in the front seat are Grandpa Warren, Ida Warren, and Henry Warren. Grandma Warren is in the back seat.

In 1834, the ell was on the lot when John Hancock obtained the property from Charles Sessions. It exchanged hands several times. In 1840, the Ames family sold this house to Marcus Beebe, who manufactured plows, wheelbarrows, and a variety of farm implements. Here, Rev. Edward Everett Hale, author of *The Man without a Country*, officiated at the marriage of his friend Rev. Calvin Stebbins to Lucinda Beebe, daughter of Marcus Beebe.

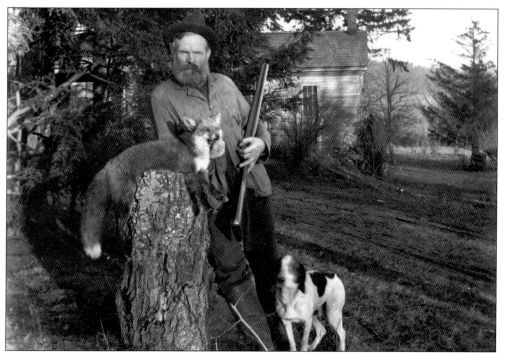

Like most men of that era, Charles H. Burleigh not only farmed but was a hunter. He is shown with his faithful dog and gun. Undoubtedly, the fox had raided his chicken coop.

This lovely old house on Main Street belonged to Anna McCray, seen here with her dog as she spruces up the yard. The shaded porch gave a welcomed respite from the heat on a blistering summer day.

This plot of land on Glendale Road exchanged owners several times. James Vineca bought it in 1857 and must have built the present house. He sold it to Abraham and Frances Whitehouse in 1857, after which the house changed owners many times until it was bought by Reginald Temple in 1939. The "tramp house" is located in the rear.

This small building was called the "tramp house" when the land and larger home was owned by Louis Luddihke. Tiring of taking tramps into his own house for the night, he built this 11- by 14-foot building that had room for a chair, wood-burning stove, bureau, and double bed. Hampden had no town farm as other communities did, so the town reimbursed Luddihke 40¢ for each tramp he put up for the night. Many of these wanderers made the rounds of mills at different seasons, looking for work.

Edward P. Lyons built this modern-looking cottage, with its screened-in porch, on Bennett Road in 1932.

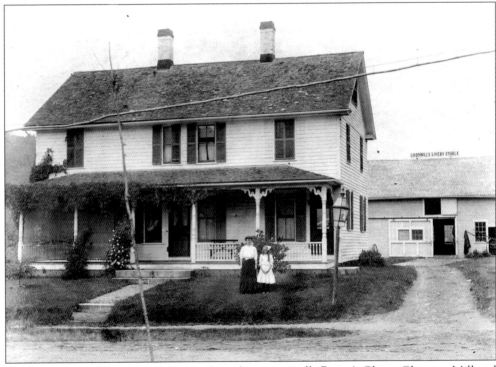

This house (now standing at 527 Main Street) was originally Roper's Clover Cleaning Mill and was erected on the bank of the Scantic River. Once it was moved to where it now stands, it was used as a boardinghouse for workers at the Lacousic Woolen Mill. A livery stable once was operated here, and the last hearse owned by the town was kept in one of its sheds.

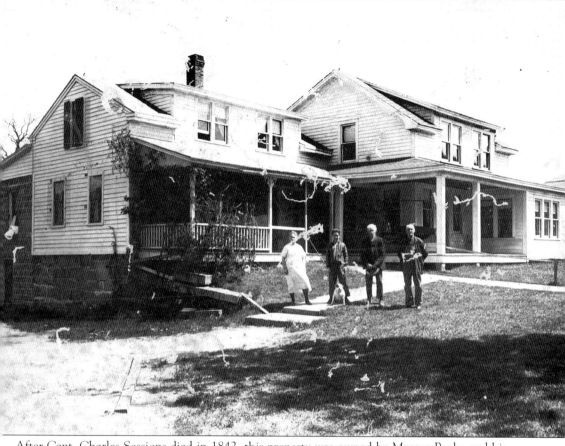

After Capt. Charles Sessions died in 1842, this property was owned by Marcus Beebe and his brothers, who added an ell. In 1866, the Beebes sold it to Amos Whitaker, who was one of the early stage drivers to Springfield. His daughter Mary A. Bradway sold the house to Edward P. Lyons in 1911. When the upright part burned to the ground in 1918, the main part of the present house was built by Lyons. The odd marks on the photograph are imperfections caused by the passage of time.

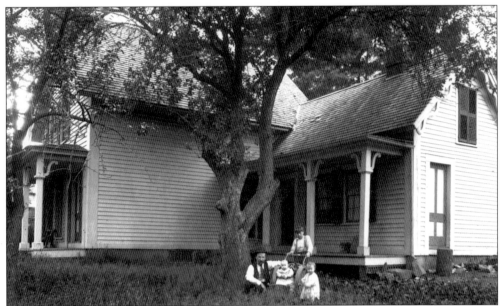

This house at 413 Main Street was built by the son of Eleazer Scripter and exchanged hands a few times before Alonzo Noble lived here in the early 1900s. Unfortunately, when Alonzo Noble's son LeRoy Noble was frying doughnuts one day, the house caught fire and burned down. The present house on this site was built by Nelson M. Carew. (Howes Brothers Photos, courtesy of the Ashfield Historical Society.)

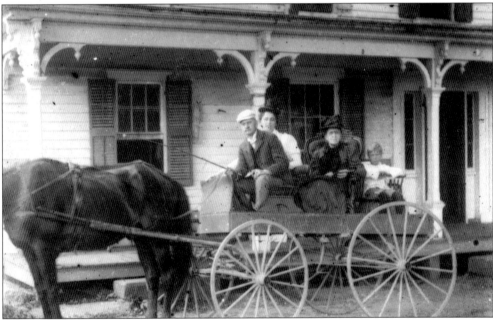

The front of the Bliss-Morris house on South Road is shown as it looked in the early 1900s. This house was once a station on the Underground Railroad. Setting out on an errand are, from left to right, Frank S. Smith and his wife, Elizabeth McIntire, and Harvey O. Smith. Note that the passenger seats on this conveyance face the side of the vehicle. They appear to be chairs brought from the house.

This 1925 photograph shows the kitchen of a South Road house owned by E. Norton Davis. On the left is a Hoosier cabinet, now a collector's item. Its counter could be extended to make more room if the cook was setting rolls for baking. Often, a flour sifter was built into an upper cabinet. Houses at that time were built with spacious pantries instead of the modern wall cabinets in use today.

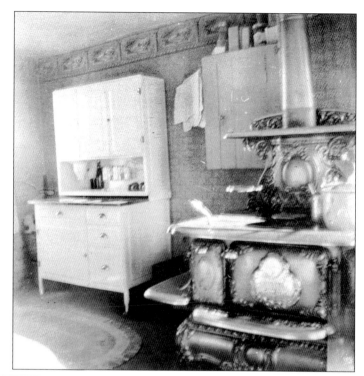

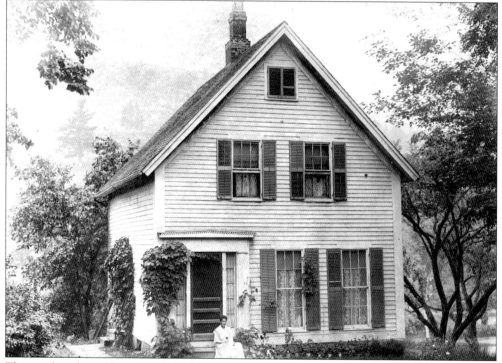

This is thought to be one of the houses built by Eleazer Scripter to house workers at the Lacousic Woolen Mill. Many of his houses featured decorative scrolls under the eaves, although some subsequent owners removed this decoration. Elmer Soper bought this house in 1925.

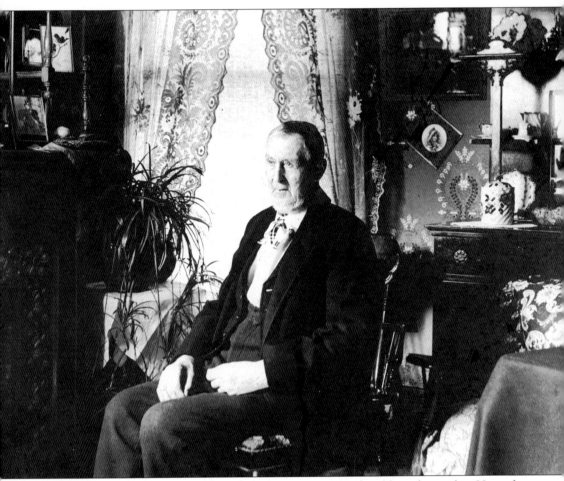

In this early-1900s photograph, Corridon Root poses comfortably in his parlor. His wife was Myra Brace, who kept many knickknacks and house plants in this delightful room showing the décor of that era. They had one daughter, Elva Root, who was born on February 24, 1854, in what is now Hampden.

Picture the surprise of the Davis girls when they awoke on Christmas morning to find their very own Christmas tree. There were no electric lights decorating the tree, but garlands took their place. Wrapped packages are ready to tempt the girls, and the stove will keep the youngsters warm.

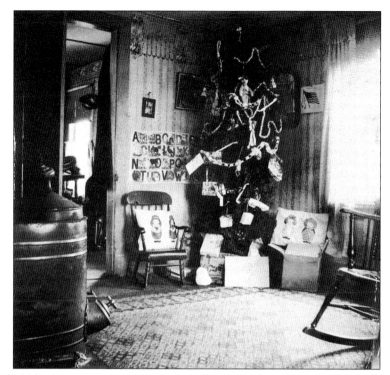

William Stacy settled here in 1749. Either his son Ebenezer Stacy or his grandson Loren Stacy is believed to have built this house. Loren Stacy paid more taxes than anyone in town in 1833. Toward the end of the 19th century, Albert Lee and his family lived here and are shown in this photograph. In the early part of the 20th century, a kettle of water was being heated over an outdoor fire for butchering. Unfortunately, sparks from that fire set the house ablaze and it burned down. Later, Lee built another house here.

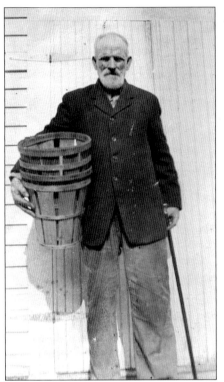

Charles Henry Burleigh holds peach baskets. Sunny-Side Farmhouse stood at the intersection of North and Burleigh Roads. It was bought in 1844 by Abner C. Burleigh, who raised fruit trees. A later owner used a two-room house on the property as living quarters for indentured workmen from Poland, laboring in the dairy and barns until they earned enough money to buy their passports. After the demise of the old farmhouse, a new one was built. E. Norton Davis and his wife, Louise Burleigh Davis (great niece of Abner Burleigh and granddaughter of Charles Henry Burleigh), bought the farm in 1932 and commercially grew apples, pears, plums, peaches, and grapes. Her close first cousin Dr. I.R. Calkins was a former world champion revolver shot and he instructed her in the art. One day, she shot a deer in her front yard. In Calkins's Springfield office and under his direction, she removed the tonsils of her daughter Molly Davis.

# Six

# FAMOUS FOLK

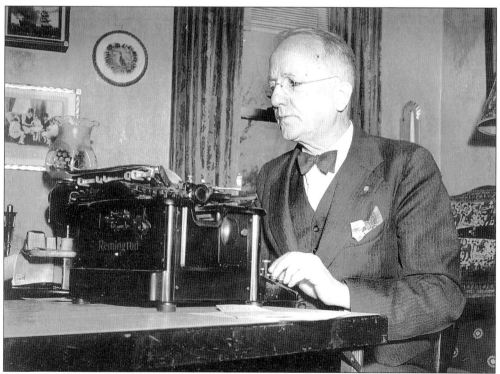

In the early 1930s, renowned storyteller and naturalist Thornton W. Burgess purchased his Hampden house. He lived there until his death. On this Remington typewriter, he wrote his tales of Peter Rabbit and the Old Brier-Patch, Reddy Fox, and Jimmy Skunk, turning out more than 15,000 stories and 170 books in his lifetime and receiving accolades and awards from around the world as he taught children to appreciate nature.

Thornton W. Burgess lived in this house, shown in 1928. He purchased it in the early 1930s. It was constructed by Calvin Stebbins, the son of Moses Stebbins, one of the first settlers of Hampden. The back of the house is built into the side of a hill, with the cellar as on the first floor. Stone walls three feet thick keep the cellar above freezing in winter and cool in summer. The steps of the staircase to the upper floor are only three inches wide, with six inches between steps. The fireplace in the kitchen contains a huge bake oven. In a small cabin on the hill above the house, Thornton Burgess wrote his nature stories until age made it difficult for him to climb the hill any longer.

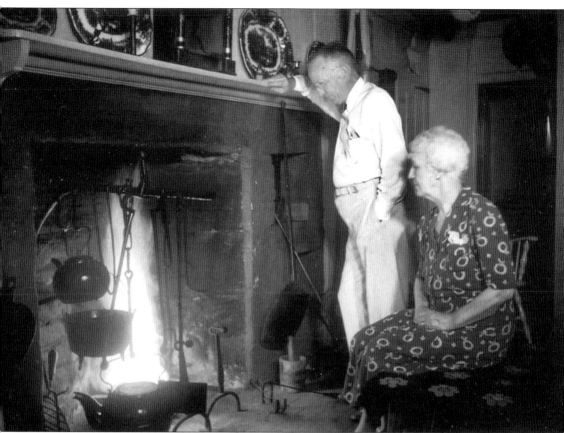

This photograph shows the interior of the house owned by Thornton W. Burgess, who is shown with his wife, Fanny Burgess, in their delightful home. Now owned by the Massachusetts Audubon Society, the property has Laughing Brook Education and Wildlife Center's trails, which are open year-round, and a preschool on the premises. Classes on various subjects are held for adults, children, and families. At specific times, tours of the house are given. Buses bring schoolchildren to learn about nature.

Ernestine Johnson, herself a published writer, was secretary to Thornton W. Burgess. Shown here taking dictation, she enjoyed being with Burgess and continued to work for him after he became ill and resided in a nursing home.

Anice Stockton Terhune—who was a noted writer of 15 published books and was a concert pianist and composer—was born on South Road. After her mother, Lillie, died (leaving several children), her father kept the three youngest with him and moved to New Jersey, later marrying again and having four more children. Various relatives brought up the other youngsters. Terhune is shown here with her great-aunt Elizabeth McIntyre, with whom she lived until she was grown. In the winter, she and her great-aunt lived in Springfield, but they always moved to the Hampden house for the summer.

Anice Stockton Terhune, right, is shown with her sister Bessie. Originally, she was named Annie, but an ancestor was named Anice and she took that name as her own, feeling it was more sophisticated. Three of the 15 published books Terhune wrote, such as *Eyes of the Village*, were based on people in Hampden. Characters were given the names of actual people who lived in the town, but the names were assigned to the wrong people. Residents were eager to figure out which characters were based on which real residents.

Anice Terhune's niece Frances Stockton (later Jones) is shown enjoying a book, perhaps one written by her aunt. Frances Stockton was a historian, eager to keep alive all the elements of the town's past and working hard to do so. She compiled and edited *Hampden Centennial Souvenir Program 1878–1978* and collaborated with Carl Howlett on his book on early Hampden. She was one of Hampden's treasures.

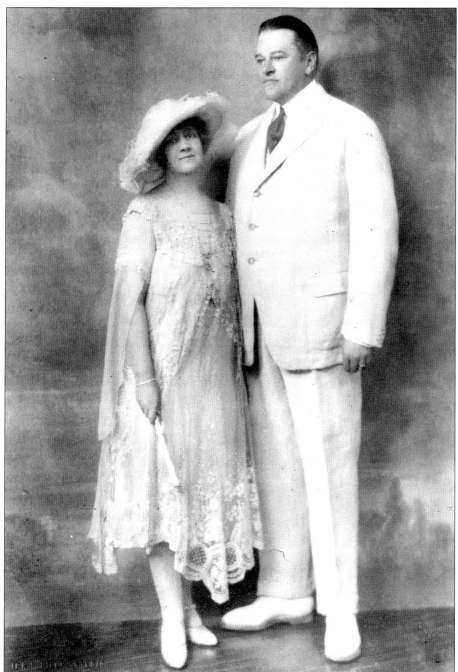

Anice Stockton married Albert Payson Terhune, noted writer of stories about dogs. This photograph was taken on September 2, 1926, on the couple's 25th anniversary. For the celebration, the Terhunes hired a railroad car to bring their friends from New York City to their home at Sunnybank in New Jersey, which is still open to the public. The gown is in Hampden's museum. After her husband's death, Anice Terhune wore only white or black. A niece remembers her being driven to Hampden by her chauffeur. She was always a lady, dignified and Victorian.

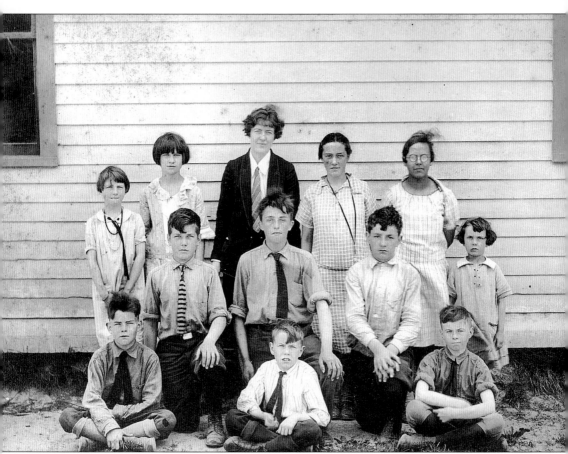

The first job taken by renowned aviatrix Maude Tait was as schoolteacher to Hampden children. Here, she is pictured with her class in the 1920s. From left to right are the following: (front row) three unidentified brothers; (middle row) Howard Hatch, Chester Pease, and Reginald Temple; (back row) Bernice Snow, Madeline Gunther, Maude Tait, Rachael Pease, ? Braton, and Dorothy Hatch. Maude Tait gave each child a flashlight for Christmas. One day her father sent to the school two limousines with jump seats, which picked up the members of her class and took them to Springfield, where they were treated to ice cream formed in a variety of shapes. Her parents moved from Springfield to Hampden in 1929, and her nieces still live here.

Maude Tait stands to the right as she and Mary Herlihy make ready for a ride. Sometimes, a couple of the boys from her class accompanied her to Springfield when school was over for the day, and she took them up in her plane. She was the first woman, both in Massachusetts and Connecticut, to receive a pilot's license and later became the first woman to receive a commercial pilot's license. She set an altitude record of 16,500 for women.

Maude Tait, left, relaxes with Mary Herlihy. In Cleveland, Ohio, in 1931, she set a speed record of 214.9 miles per hour, faster than any other woman at that time (10 miles per hour faster than Amelia Earhart), and missed the men's record by only 1 mile per hour. She flew her own plane, a Model Y Gee Bee made by the Granville brothers. She gave up flying after she married James Moriarty.

# Seven

# CLUBS, MONUMENTS, AND PARADES

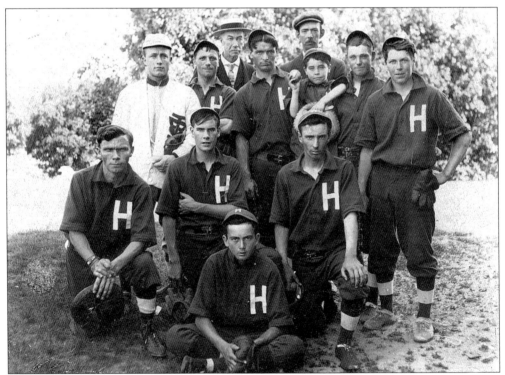

In 1908, the original members of the Valley Nine baseball team pose for posterity. From left to right are the following: (first row) Cliff Bradway; (second row) pitcher Frank Perry, Raymond Burleigh, and Francis Eldridge; (third row) captain ? Stone (from Springfield College), unidentified, Henry Luddecke, mascot Louis Lyons, Bill McCray, and Robert Brown; (fourth row) managers Marc and Gilbert Beebe.

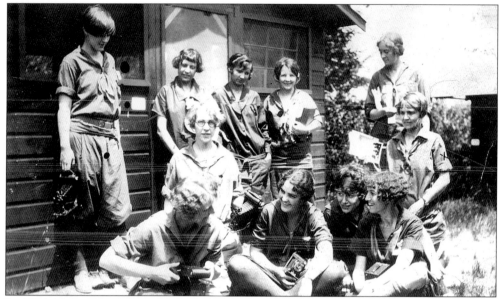

In 1926, Nettie Gottsche started the first Girl Scout troop in Hampden, one of the first in Massachusetts. Later, she performed a ritual with her grandchildren. At their knock, she knelt and peeked through the keyhole. They peered back. Once, when dyeing wool for hooked rugs, expecting the children, she knelt, looked through the keyhole, and was so flustered at seeing a man's waistcoat instead of the expected child that she flung open the door and said, "I'm dyeing," and he thought she was.

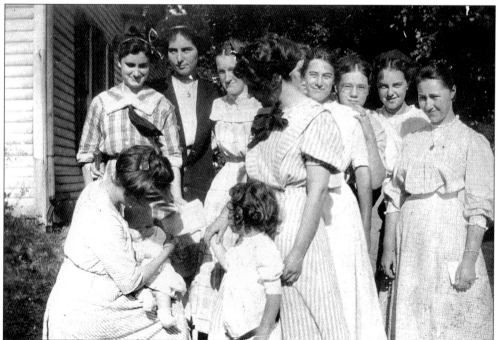

The Mawr-Rhys Club was very active in 1905. Mawr-Rhys was the name of a Welsh prince. Perhaps a reader may tell us the purpose of the club. A house on South Road was called the Mawr-Rhys House.

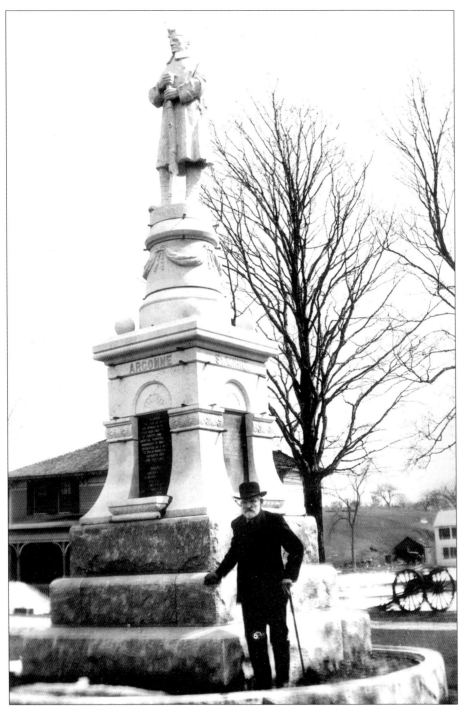

Charles Henry Burleigh poses beside the World War I monument that he donated to the town. The soldier gracing the top of the monument was carved by a Monson man, Ezio DeSantis. This was one of the first world war monuments in Massachusetts. Now, each Memorial Day (as on Decoration Day in the past), the parade ends at the monument where speeches are given, memorializing those who have gone on.

The Leach Monument stands amongst the trees on a hillside across from a Main Street auto-body shop. Here, Isaiah Leach was cutting trees in 1816 when a log fell from his sled, killing him. The monument in his honor still stands, but the lettering has been obliterated by time.

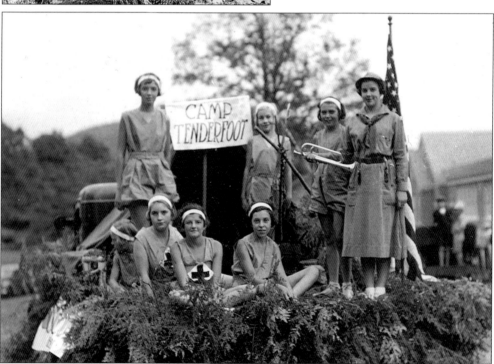

In this 1930s image, Hampden's Girl Scouts pose on the flatbed of a truck, ready for the parade. Note the more modern uniforms. From left to right are the following: (front row) May Morse, Marion Davis, Lorna Harris, and Winifred Medicke; (back row) Mary Copperthwait, ? Metcalf, Delphine Howlett, and Elizabeth Strand. (Photo courtesy Springfield Newspapers.)

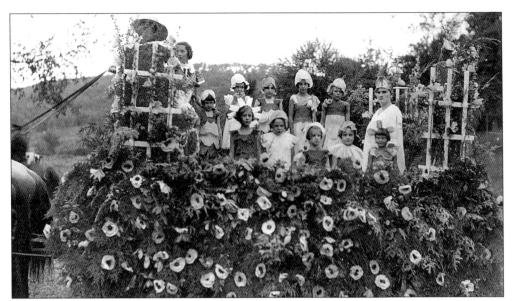

In 1935, Hampden's mother town, Wilbraham, celebrated its sesquicentennial with a parade for which the Hampden Garden Club decorated this beautiful float. The youngsters are as pretty as the posies. From left to right are the following: (front row) unidentified, Barbara Burleigh, unidentified, Betty Jean Burleigh, and Lucille Temple; (back row) ? Fuller, Betty Fuller, Geneva Asher, two unidentified girls, Phyllis Asher, ? Bassett, Marilyn Fisher, and Sylvia Davis. (Photo courtesy Springfield Newspapers.)

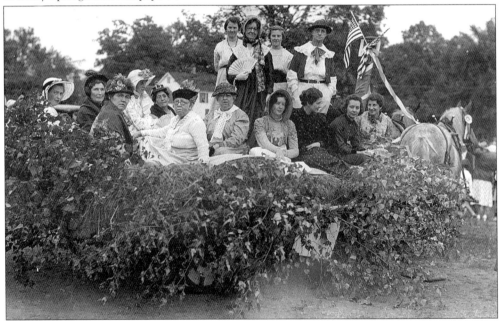

This lovely float was put together by the Catholic Women's Club for the 1935 Wilbraham sesquicentennial parade. From left to right are the following: (front row) Margaret Witkop, Ethel Roux, Gertrude Lyons, Helen Flynn Enslin, ? Curtin, ? O'Brien, unidentified, Bernadette Roux, ? Duquette, ? Roux, and ? Duquette; (back row) three unidentified women, and ? Rutherford. (Photo courtesy Springfield Newspapers.)

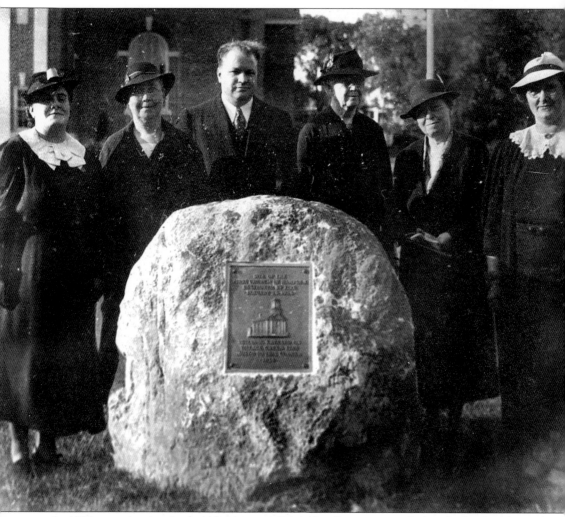

In 1932, a native granite boulder memorializing the Congregational church that had burned down was placed on the town house lawn. Present at the dedication are, from left to right, Eleanor B. McCray, Mary Isham, ? Sizer, Elizabeth Sessions, ? Ely, and Louise Burleigh Davis.

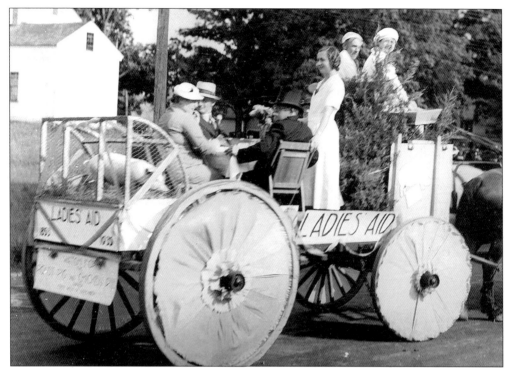

This photograph from the sesquicentennial parade in Wilbraham shows members of the Ladies Aid Society depicting their annual roast-pig-and-chicken-pie supper. Edward J. Thresher is driving, with Betty Scheibler seated next to him. Muriel Pease Curtis is standing. Seated, from left to right, are Mrs. Neil Kibbe, unidentified, and Frank A. Heath (wearing the silk hat). (Photo courtesy Springfield Newspapers.)

This is the wagon that took the place of a bus in the days when children were taken to school by horse and wagon. The roof provided protection from the elements during inclement weather. The school wagon is now on display at the museum run by the Historical Society of the Town of Hampden. (Photo courtesy Springfield Newspapers.)

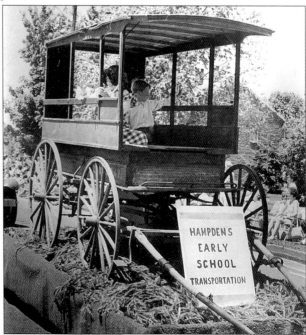

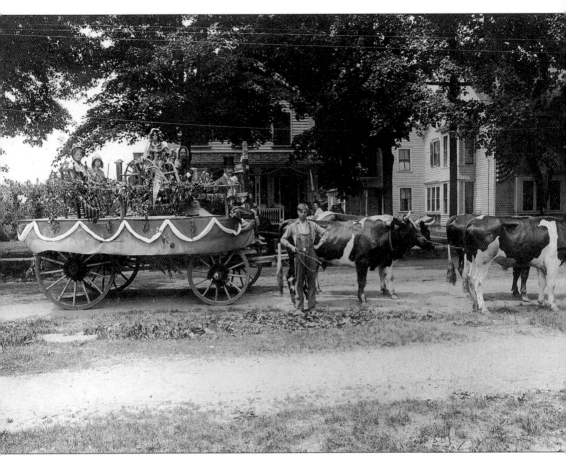

The southernmost part of Wilbraham was called South Wilbraham until it became Hampden in 1878. Hampden took part in Wilbraham's sesquicentennial parade, this being its official float. This photograph was taken on Hampden's then unpaved Main Street. On the float, from left to right, are Adella Crocker Pease, Lena McCray Keeney, Anna Leach McCray, Mary Sessions, Lincoln McCray, and John Flynn. William McCray stands behind the fine team of McCray oxen. The woman behind the oxen is unidentified.

*Eight*

# PLAYS AND PASTIMES

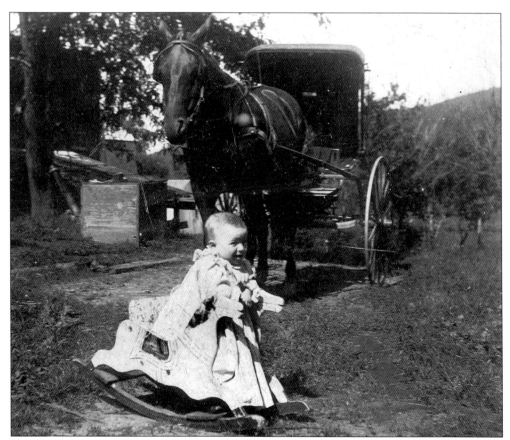

Harold Woodworth Sr. is only a toddler in this nostalgic scene as he gallops on his rocking horse. The real horse stands sedately, watching its young charge at William Leach's home on Somers Road. William Leach was Harold Woodworth's grandfather.

In the early 1900s, Louise Lee, wife of Albert Lee, leads a horse and pauses in front of her South Road home as she waits for her daughter.

Standing on the foundation for the Springfield Mountains Creamery on Riverside Drive in 1913 are Esther Burleigh (left) and Gertrude Lyons. The Scantic River streams slowly past. Farmers once brought their cream here to this cooperative run by farmers in the area.

In 1910, James and Louis Lyons stand in front of the Congregational church, which did not burn until 1923. The Howlett house can be seen at the left in the distance. Today, the town house stands where the church once did, and the former Howlett house is on the corner of North Road, which joins Main Street at this point.

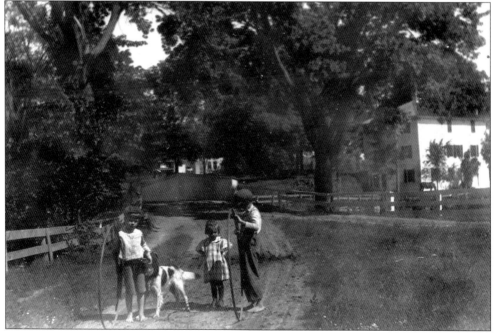

Walking down the lane seems to be a way of life in this country scene in the tranquil village. The carefree children, Earl and Maud Howlett, play with their hoops. The other child is unidentified.

In June 1898, these young girls take time from a busy afternoon to pose on the steps of the Moody house. From left to right are Linda Beebe, Mary Isham, Carrie Moody, and Annabel Isham. Shirtwaists and long skirts were the fashion.

This adorable photograph of Gertrude Lyons and her older brother, Harry Lyons, was taken in Hampden. The house in the background is at 4 South Road. Harry Lyons died at the age of 26. The wheels on the cart the children are pulling are much larger than those used today. Gertrude Lyons was another town treasure, doing her utmost to preserve Hampden's history.

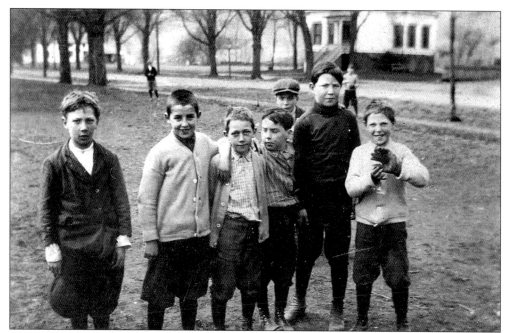

This shows how wide open Main Street was in 1913. There was plenty of room for boys to play ball. From left to right are Joseph Bandoski, unidentified, Arvid Larson, Louis Lyons, Ray ?, Pat Linnehan, and Walter Larson. The youngsters in the background are unidentified.

The play *The Family Album* was put on for the benefit of the Baptist Church Society *c.* 1908. This photograph was taken in the home of Laura Shute. From left to right are the following: (front row) Rose Ballard, Julius Gottsche, Madeline Kenworthy, Rose Corey, Marcus Gottsche, and Russell Kibbe; (back row) ? Green (a teacher), Helen Kibbe and her mother, Elsie French (later Pease), and ? Johnson (a teacher).

At Academy Hall in 1908, these stalwart Native Americans put on a Kickapoo Indian Show. Nettie Gottsche said, "My mother bought some of their beadwork. They sold Kickapoo Indian Snake Root medicine and worm lozenges." The brave and papoose wear feathered headdresses, while the Native American maid's hair may never have been cut.

This group of thespians put on a play in Academy Hall in 1903. Howard Ballard is lying down. Others in the picture include Gilbert Beebe, Florence Lee, John Isham, Linda Stockton, John Stockton, Marcus Beebe, and Louise Smith.

This 1915 photograph shows those who performed at an old folks concert. From left to right are the following: (front row) Laura Shute and Mrs. Arthur Deane; (middle row) Mrs. Frank Stockbridge Smith, Mina Sessions, Etta Beebe, Nettie Gottsche, Lillian Goodwill, Florence Ballou, and Adelle Pease; (back row) Leroy Noble, Charles S. Shute, William V. Sessions, unidentified, Rev. Joseph Sullivan, and Arthur Deane.

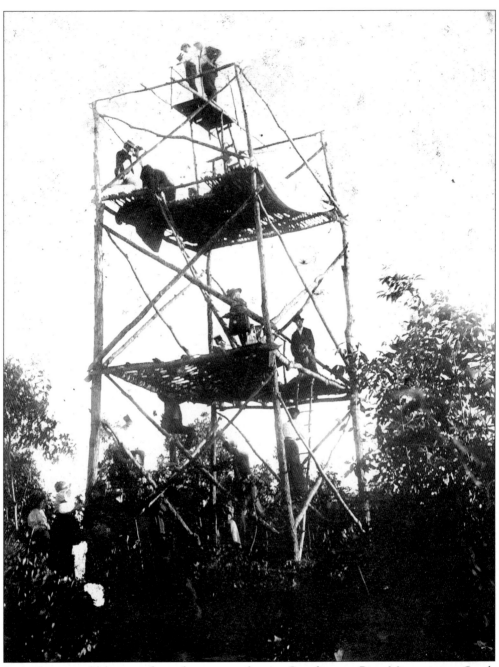

Lee's Tower could be seen from the center of town. Standing on Pine Mountain on South Road, high above the village, it was built by Albert Lee as a recreational site for young people, but oldsters enjoyed it, too. "It was such fun," one woman remembers. "It was a little rickety but we loved to climb it. You could look down into Connecticut." Picture the picnics, the boiled eggs and chicken, the potato salad, and homemade rolls consumed by people eager to make merry at the tower. Nearby, Albert Lee erected a dance hall to add to the enjoyment, so the lilting strains of a waltz might drift along the night air, adding an aura of romance to Lee's Tower.

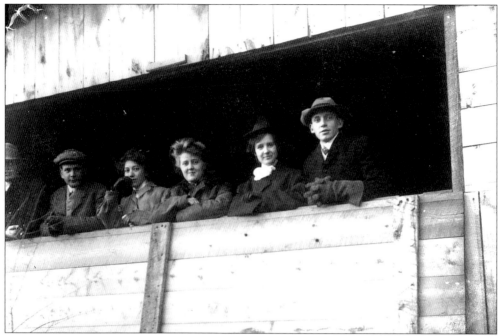

Near his tower, Albert Lee built a dance hall. Later, this was moved down the mountain and used as a barn. In this photograph from the early 1900s, warmly clad young people gather for "a night on the town." The young woman second from right is Louise Stockton. The others are unidentified.

It was a windy day when these Hampden young people climbed the tower to gaze off into Connecticut. Ted Smith is in front. The others are, from left to right, John Stockton, Linda Beebe, Florence Lee, ? Smith, Louise Stockton, and Howard Ballard.

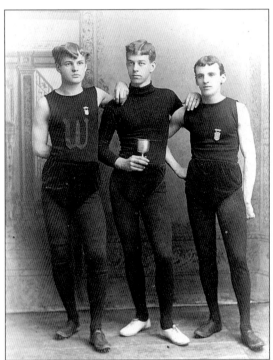

In a sporting event, C.S. Ballard (center) made Hampden proud when he ran a mile in 5 minutes and 23 seconds. He holds the trophy. With him are T.G. Robbins of Lowell (left), winner of the 100-yard dash with a time of 10¾ seconds, and Ed Clark of Lexington, Kentucky (right), who ran 200 yards in 23½ seconds.

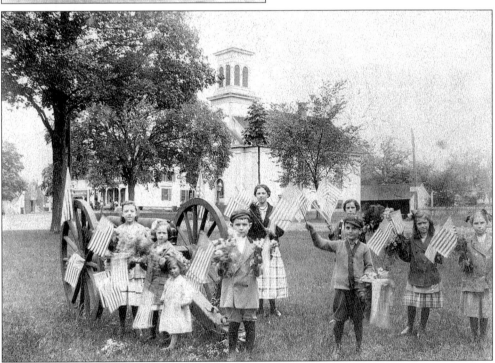

Decoration Day was a big event in the early 1900s. These Hampden young people are gathered on the village green. From left to right are Madelene Kenworthy, Dorothy Kenworthy, Leonice Kenworthy, Hazel Thresher, Helen Thresher, Carl Howlett, Edward Burleigh, Anna Burleigh, and Esther Burleigh. The Congregational church is in the background.

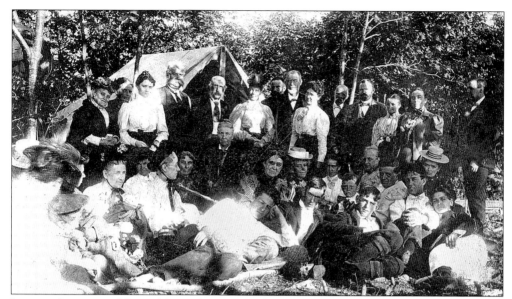

In times long gone, Mount Minnechaug was a favorite spot for camping and for picnics on a fine spring day. These unidentified people appear to be having a good time despite their apparel. Town couples gathered to sing around a campfire and enjoy picnic goodies. The only difference between then and now appears to be picnic attire. Imagine being weighted down with heavy skirts, long-sleeved shirtwaists, and bonnets that tie under the chin. Men favor suits.

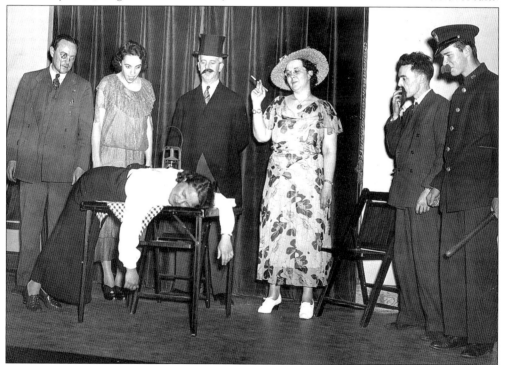

In 1939, the Hampden Dramatic Club put on a play at the town house. Florence Lunden lies draped across the table. Wearing startled expressions, the other players are, from left to right, Bill Breck, Ann Berte, Dr. Harold Bennett, Ernestine Bliss, Fred Medicke, and Lee Taft.

Carl Howlett put his free time to good use, painstakingly researching the history of the houses and churches in town, always eager to learn more about those who lived here earlier. His book *Early Hampden* and his other publications are invaluable to anyone interested in Hampden history. We are indebted to him for all his hard work, his pastime of preserving knowledge of the past for those in the future.

Miriam Perkins Bryans, a beloved Hampden elementary school teacher, also deserves the heartfelt thanks of Hampden's citizens. Her book *A Century Walk along the Scantic 1878–1978* was published in time for Hampden's centennial celebration. Like Carl Howlett, she was a native of the town and researched the businesses along the Scantic, giving future citizens a way to learn about the past.

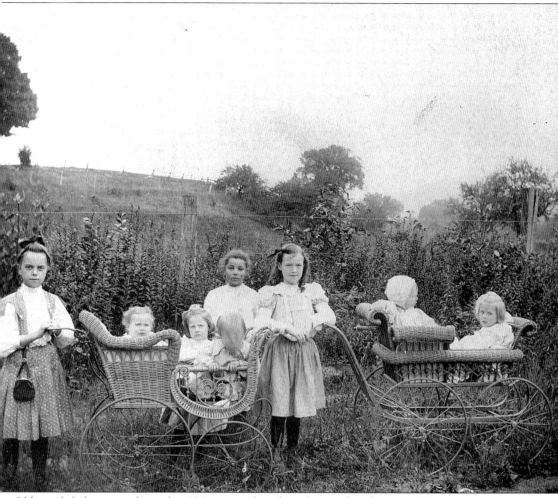

Older girls baby-sat in the early 1900s just as they do today. In this photograph from that time, they walk in a meadow on South Road with the youngsters in their care. Note the high wheels on the rear of the baby buggy to the left and the small ones in front. From left to right are Mabel Davis, Stacy and Vivian Hunt, Grace Terry, Arline Howlett, Carl Howlett, unidentified, and Madeline Beebe.

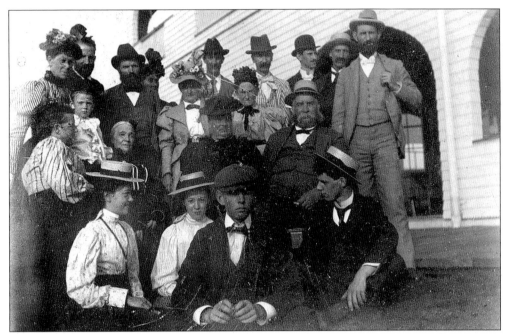

In 1900, this group of Hampden people took a jaunt all the way to Mount Tom for a picnic. From left to right are the following: (front row) Linda Stockton, unidentified, Gilbert Beebe, and Howard Ballard; (middle row) ? Ballard, Walker Holmes, Nellie Read, Esther ?, and ? Ballard; (back row) Susan Beebe Burleigh, Lucius Beebe, Charles Henry Burleigh, unidentified, Adelaide ?, D.L. McCray, ? Turner, Mark Beebe, Rev. Charles .B. Bliss, Albert Lee, and ? Holmes.

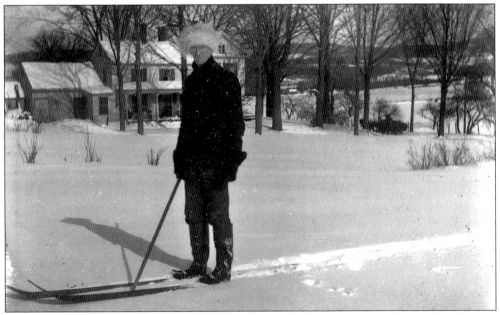

Raymond Smith, wearing a large knitted hat, skis on South Road in the early 20th century. He took many pictures of Hampden c. 1900. The house in the background in this view was called Seven Maples.

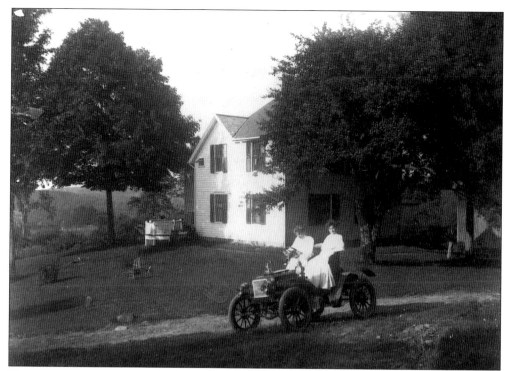

Two young women try out Raymond Smith's car in the early 1900s. The Mawr-Rhys House stands on the east side of South Road in this scene captured in the early 1900s.

Women photographers were seldom seen c. 1900, but Hampden had its own, a Miss Metcalf, who lived on South Road. She took this photograph of Elizabeth Brennan of 368 Main Street (grandmother of Betty Dunlea Connors, Edwin Dunlea of Chapin Road, and Donald Dunlea of Springfield), seated, and her cousin Bessie Brennan.

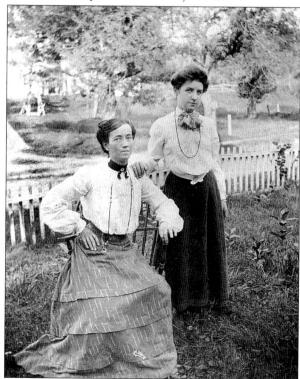

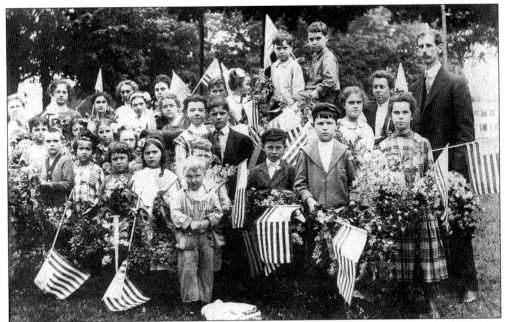

In the old days, people gathered at the cemeteries after the parade, laying flowers on the graves and meeting friends who had traveled from miles around to visit town on this important day. In this view, Hampden schoolchildren gather with Rev. Charles B. Bliss (right). Note the bouquets of flowers the children have picked for Decoration Day (now known as Memorial Day).

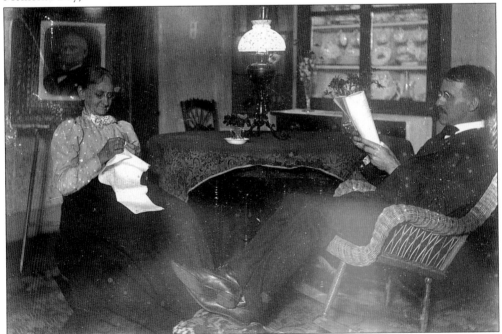

Durrell Pease and his mother are shown in this photograph from the early 1900s. During a relaxing evening at home, she busily plies her needle while he catches up on his reading. Durrell Pease was a noted inventor and lived for a time in England.

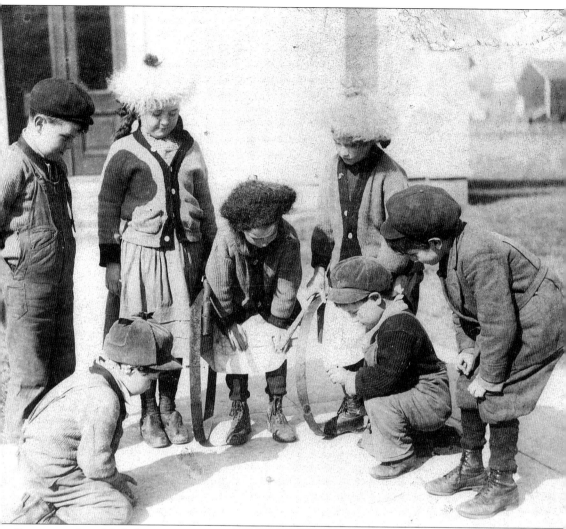

Youngsters knuckled down to games of marbles from the early 1900s, as shown in this photograph, to the 1940s. Requiring considerable skill, the game spawned contestants who vied across the country for the world championship. If it makes a comeback, today's children may find the game more fun and more difficult than they imagine. Harry and Gertrude Lyons stand at the left. Ed Burleigh has just shot a mooney into the center of the ring while Anna (leaning forward) and Esther Burleigh watch. James Lyons squats for a closer look at the shot. Louis Lyons is on the right.

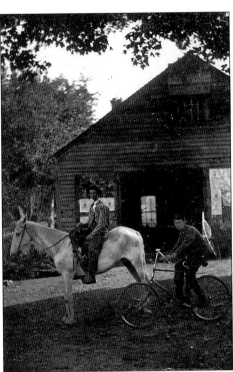

This tintype shows two means of early-20th-century transportation. Perhaps these lads on horse and bike are planning to race.

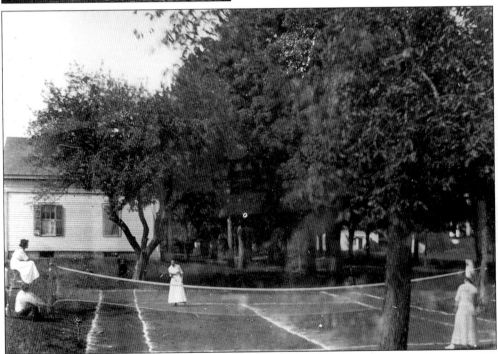

These young women are enjoying a game of tennis on the court that once stood between 612 Main Street and Riverside Drive. The Epaphro Day house, shown in the background, burned in 1923. Rev. Charles B. Bliss and the young people of the town worked hard to make a place to bat tennis balls. The court was very popular.

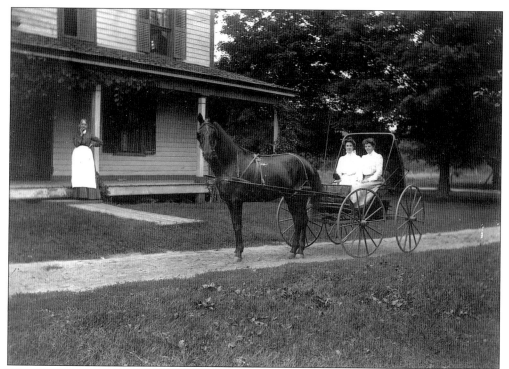

Ellen Pease watches her daughters Emma and Grace as they set off on a carriage ride with the top down in the early 1900s. The horse seems eager to pose for the picture.

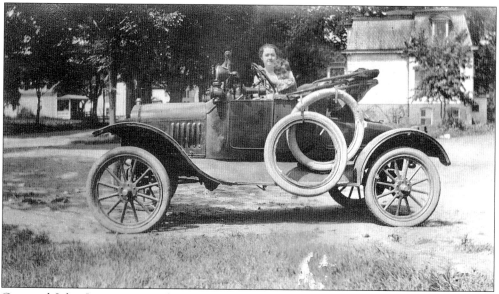

Gert and John Lyons are out for a spin in this snappy automobile. Note the novel way of carrying spare tires, a necessity in the days when roads were poor and flats occurred often.

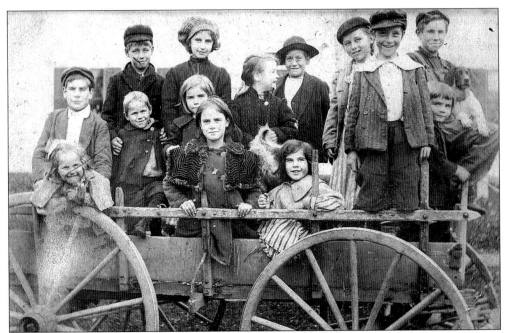

Pictured is a cartload of happy youngsters. The children are identified by sections from front to back, starting at the left: Madeline Hunt and Raymond Burleigh; Stacy Hunt and unidentified; Eleanor Burleigh, Anna Burleigh, and Louise Burleigh; unidentified and Gertrude Lyons; Howard Palmer and Hattie Palmer; and Edward Burleigh and Charles Burleigh.

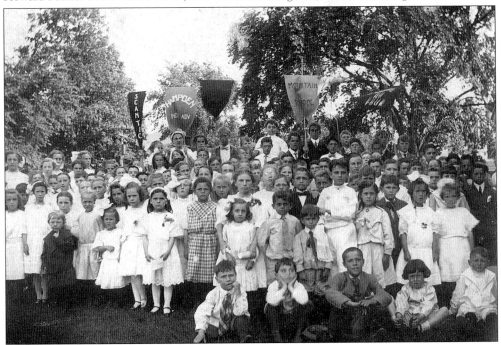

Banners are held aloft by these Hampden young people during Decoration Day services. Note that each child is dressed in best finery. One high-flying banner reads "Scantic." Others read "Hampden" and "Mountain School."

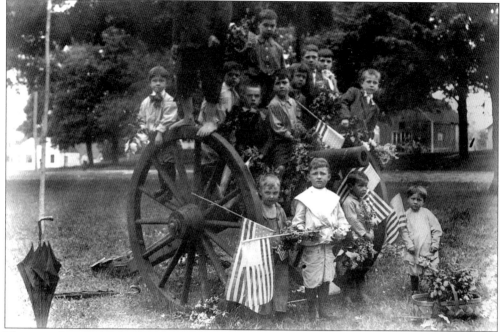

These unidentified youngsters are gathered around the cannon on the village green, their flags ready to wave as the marchers parade past. Note the rompers worn by the child on the right and the old-fashioned umbrella standing against the pole.

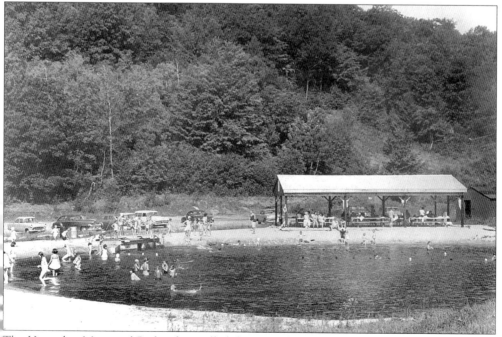

The Hampden Memorial Park, often called the "Rec" by natives, is a favorite place to cool off when the weather is hot and humid. When it was first opened, a sandy bottom eased grateful feet. There were no fences. Unfortunately, rules change and this once peaceful swimming hole has been modernized to meet with current laws.

# BIBLIOGRAPHY

Bryans, Miriam Perkins. *A Century Walk along the Scantic 1878–1978*. Hampden Centennial Committee, 1978.

*Dedication 50th Anniversary 1930–1980 Hampden Fire Station New Addition*, September 21, 1980.

Howlett, Carl C. *Early Hampden: Its Settlers and the Homes They Built*. Hampden, Massachusetts: the Yola Guild, 1958.

Howlett, Carl C. *A Short History of the Protestant Churches of Hampden, Massachusetts*. 1960.

Jones, Frances Stockton. *Hampden Centennial Souvenir Program 1878–1978*.

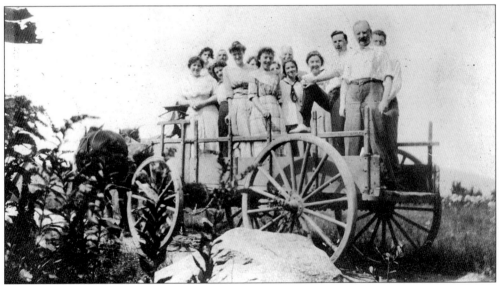

A wagonload of happy people travels along Chapin Road in 1918. Known to be in the photograph are Arline Howlett, Madeline Kenworthy Connors, Gertrude Lyons, ? Sullivan, Elmer Mulroney, ? Nutting, and Dorothy Burchard Mulroney.